Best of Friends 5

The yearbook of Creative Monochrome

Editor

Roger Maile

BEST OF FRIENDS 5
The yearbook of Creative Monochrome
Editor: ROGER MAILE
Editorial assistant: Alex Dilley
Image scanning: Nicholas Charlton

Published in the UK by Creative Monochrome Ltd
Courtney House, 62 Jarvis Road, South Croydon, CR2 6HU

British Library Cataloguing-in-Publication Data:
A catalogue record for this book is available
from the British Library

ISBN 1 873319 33 9
First edition, 1998

ISSN 1359-446X

Printed in England by Saunders & Williams (Printers) Ltd,
Belmont House, Station Road, Belmont, Sutton, SM2 6BS.

Introduction

Although digital imaging is now attracting photographers whom I had thought to be inseparable from their darkrooms, I believe it would be wrong to think of monochrome photography as an art form under threat of extinction. This fifth collection of photographs selected from over 4000 images submitted by more than 400 Friends of Creative Monochrome shows that traditional film-based, darkroom-printed black and white photography remains a popular, vibrant and vital creative medium. Although a few of the selected images have been through a digital stage, the vast majority of originals were produced using the traditional silver gelatin technology. What matters so far as the selection process is concerned is the image, not the means by which it was produced. The skill for the photographer is in using the tools and techniques which are appropriate to the 'feel' of the image.

Still photography is at a watershed of similar proportions to the effect of the popularisation of video technology on movie-making. Although digital imaging has been around for decades, it is only in the past year that I have noticed it making serious inroads into club and salon photography. There is every indication that its take-up amongst serious photographers will increase dramatically in the next two to three years. Photographers are adding computer workstations to their image-making tool kit at a prodigious rate, largely as a result of the rapid improvement in ink-jet printers and papers which have narrowed the quality gap between the photographic print and the digital print. Most such photographers remain film-based, although one suspects that the development of digital camera technology at an affordable price is the next revolution waiting to happen.

For the amateur photographer especially, digital work is particularly attractive for colour image-making, where the degree of control available to the photographer far exceeds what is available by the combination of darkroom and drum processing. For the time being, the monochrome photographic print on silver gelatin fibre paper holds the advantage in technical quality and permanence over ink-jet output. The physical qualities of monochrome photographic paper, with its wider range of surface textures and finishes, offer a more pleasing medium with the ability to hold a wider ranger of tones with smoother and more subtle gradation. One suspects that such advantages may be relatively short-lived.

For the serious monochrome worker, the main advantage of digital imaging is the ability to control contrast and tone with great precision in every area of the image. Rather than struggling with hand-masking, pieces of card, dodging wands and the like, with the familiar race against time and the knowledge that one mistake can consign an hour of meticulous work to the bin, the digital photographer can leisurely select and manipulate minute areas of an image with the option to undo errors and continue working. High resolution 'master' images can then be output to film for 'straight' silver gelatin printing, taking advantage of the delightful papers and toning effects which conventional monochrome printing has to offer.

Used in this way, digital imaging and traditional monochrome processes can be integrated, capturing the advantages of both and enhancing the image-making controls available to the photographer. Similarly, digital imaging can be used as a means of making enlarged negatives for the range of 'alternative' contact-printing processes, such as gum bichromates, cyanotypes and platinum printing.

Rather than threatening monochrome photography, digital imaging opens new horizons. Colour slide workers (and users of colour negative materials who had previously relied on trade processing) who had never before had the facilities for monochrome work, suddenly have the choice to interpret their images in tones of grey. The entry-level skill threshold is significantly reduced, encouraging more people to make monochrome images, and the fine print which was once the preserve of the dedicated and highly skilled few, becomes the province of the average digital worker.

Of course, some will resent the potential popularisation of fine monochrome printing. To see the value of hard-earned craft skills eroded by technology has been the painful lot of craftsmen over centuries, well beyond the luddites who have given their name to this understandable reaction. One positive response is to extend the depth and application of craft skills and I feel that the significant growth of interest in the 'alternative' processes and in more complex printing and toning techniques (such as lith printing and split-toning) is an indication of this. On a different level, the growth in popularity of specialist fibre monochrome papers (with all the extra work that using fibre rather than resin-coated paper entails) shows further evidence of the counter-revolution.

In total, what all this amounts to is the potential for fine monochrome photography to blossom both in the traditional and in the digital arenas. Provided the image remains of more interest to the photographer than the techniques by which it is produced, this bodes well for the future. Monochrome photography will benefit from an influx of new participants, who will bring fresh ideas and revitalise those parts of our passion which, with time, had begun to fade. And one hopes that those new participants will learn to respect and wish to acquire the craft skills which established practitioners have to offer. We live, as I am told the Chinese would say, in exciting times.

I hope the fruits of these developments in monochrome photography will be evident in the entry for the next Best of Friends and that this year's selection will provide both inspiration and motivation. To my eye, there are many delightful and diverse images in this volume and I hope they will bring as much pleasure to the 'reader' as they did to me during the selection.

The Friends groups

Creative Monochrome runs two enthusiast groups for photographers who share our belief that images are made to be seen rather than stuffed away in drawers.

The Friends of Creative Monochrome group was started in 1992 and currently numbers around 7,000 monochrome enthusiasts in more than 60 countries. Members receive a bi-monthly magazine, *Mono*, numerous special offers and a 10% discount on purchases from *CM Direct*, our catalogue of books, equipment and mono materials. The membership subscription is currently £7.50 per year in Europe (£12.50 outside Europe).

Digital Friends is a newly formed group, already numbering over 1,000 people with a particular interest in digital imaging. Members receive a bi-monthly glossy full colour magazine, *Digital Photo Art*, special offers, access to our bureau and consultancy services and a 10% discount on purchases. The annual subscription is £20 in the UK, £25 in Europe and £30 outside Europe.

One of the main aims of both groups is to give Friends the opportunity to have their own work published and to gain enjoyment and inspiration from seeing the work of their fellow members.

The address for subscriptions or further information is: Creative Monochrome Ltd, Courtney House, 62 Jarvis Road, South Croydon, Surrey, CR2 6HU (tel: 0181 686 3282, fax: 0181 681 0662; e-mail: roger@cremono.demon.co.uk).

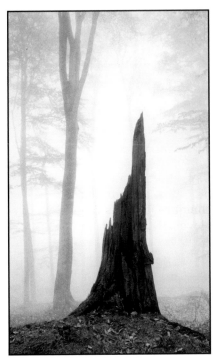

Voting for the BoF awards

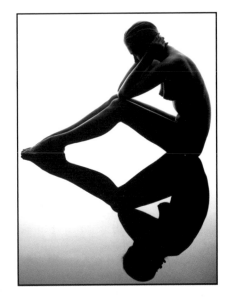

The images in *Best of Friends 5* are the equivalent of an exhibition of Friends' work. As is customary in such exhibitions, there are awards for a small number of prints which especially capture the judges' attention. Twelve medals will be awarded and the winning prints will be included in our Best of Friends 2000 calendar. All Friends of Creative Monochrome are invited to be the judges and to cast votes to determine the award winners.

Here's what to do. Each Friend has a maximum of 10 votes to award. Friends' partners are also welcome to vote. Within the limit of 10 votes each, you may allocate the votes as you see fit. For example, you can choose 10 prints to give one vote each; or you could give all 10 votes to one image; or somewhere in between. Votes can only be used in whole numbers. Friends may not vote for their own work.

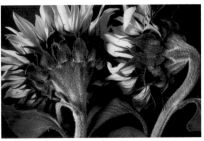

To vote, for each image selected, write down the image number (*not* the page number), photographer and number of votes awarded. Please also include your own name and address (or membership number). Send your vote to: Creative Monochrome Ltd, Courtney House, 62 Jarvis Road, South Croydon, CR2 6HU, England, **to arrive by 31 March 1999**, or vote by fax on 0181-681 0662.

The prints on this page are the six medal winners in the fourth BoF Awards (and, of course, are not eligible this time).

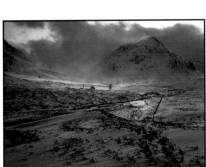

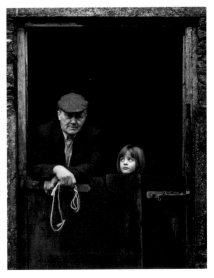

From top right (clockwise):
Trevor Legate, *Reflection* (gold); Den Reader, *Two sunflowers* (bronze); Maggie McCall, *Grandpa* (silver); Hazel Sanderson, *Sunshine after the shower* (bronze); Ken Huscroft, *Glencoe* (silver); Jiri Bartos, *Fog in Forest #1* (bronze).

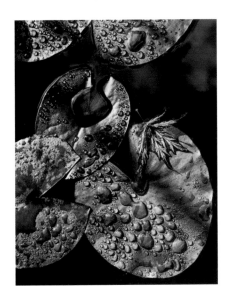

Index of contributors

(The index references are to image numbers, rather than page numbers)

Portfolio

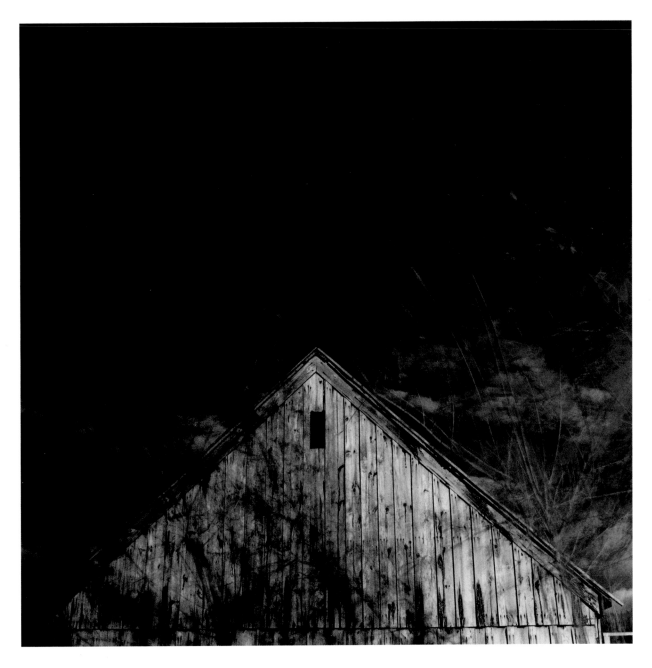

1
Shed and windy willows
Brian Poe

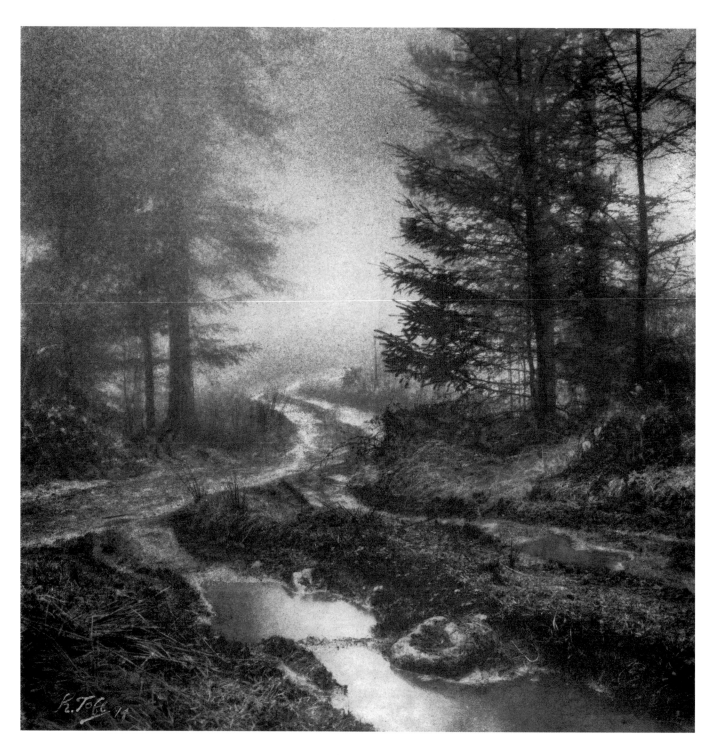

(above) 2 **December morning** *Kirk Toft*
(top right) 3 **Sunrise over Meidrim** *Richard Pike*
(bottom right) 4 **Landscape – study 1** *Bruno Caruso*

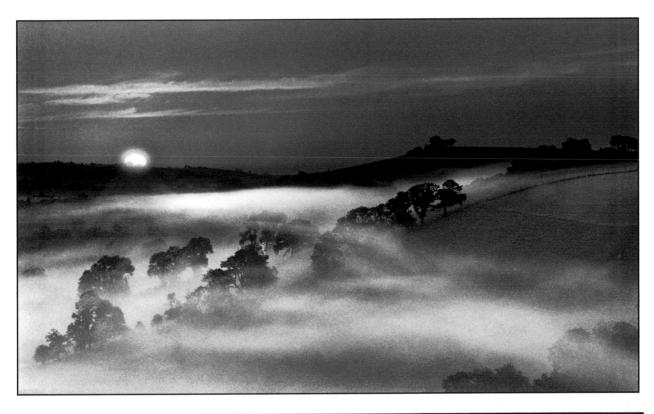

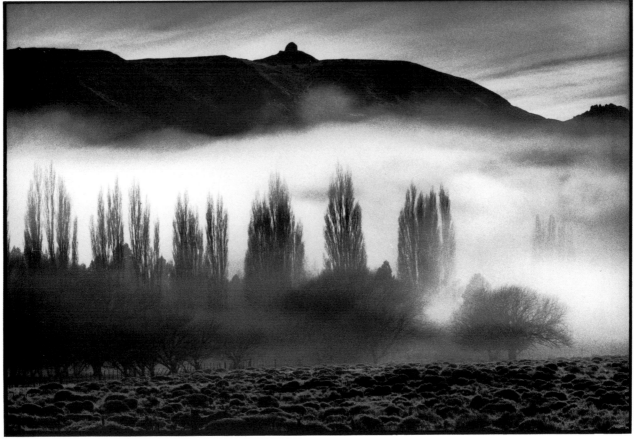

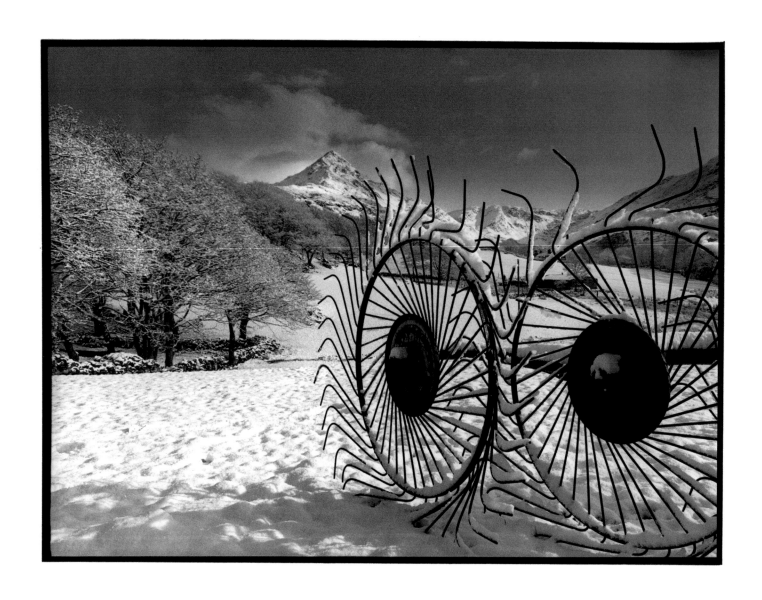

5
Hen Chwalwr Gwair
O Tudur Owen

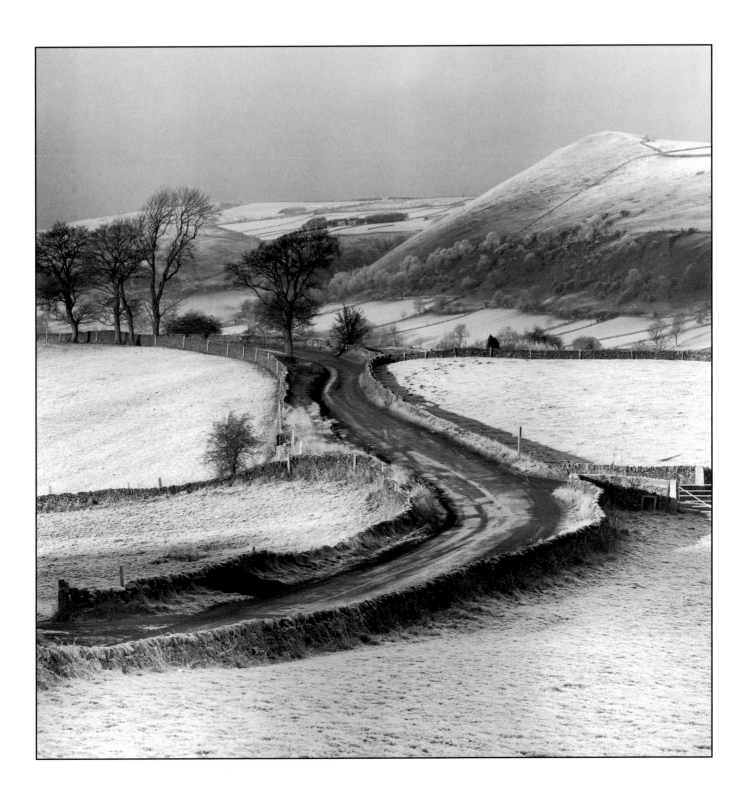

6
No title
Kevin Bridgwood

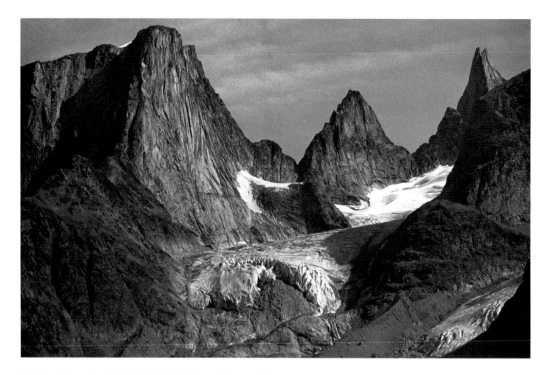

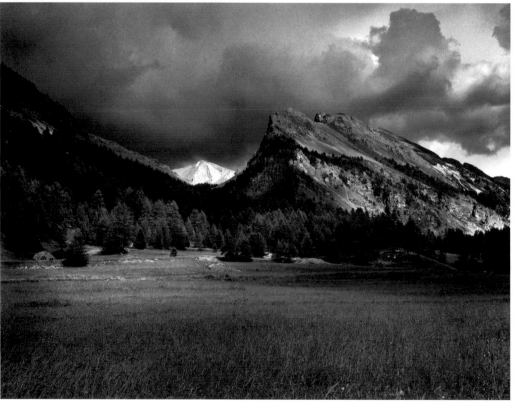

(top) 7 **Peaks and glacier, South Greenland** *Mike Chambers*
(bottom) 8 **Montagne de la Riche** *Bob Marshall*

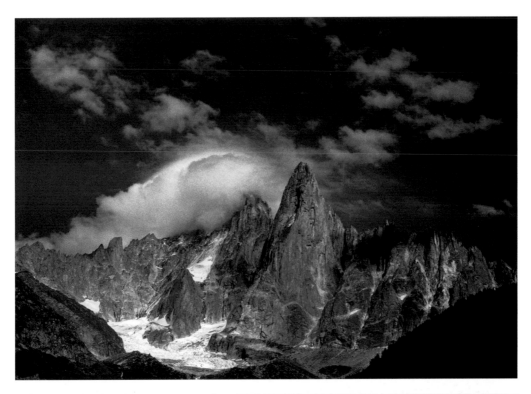

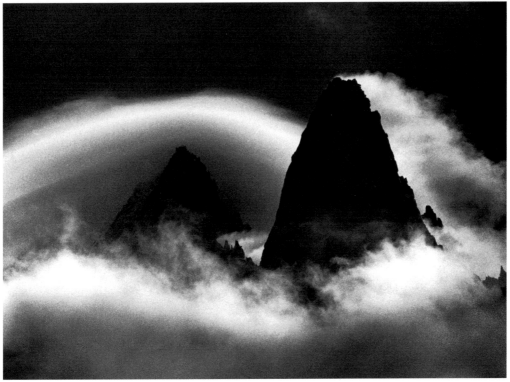

(top) 9 **Cloud over Les Dru** *Tom Dodd*
(bottom) 10 **Les Dru, 1996** *Tom Dodd*

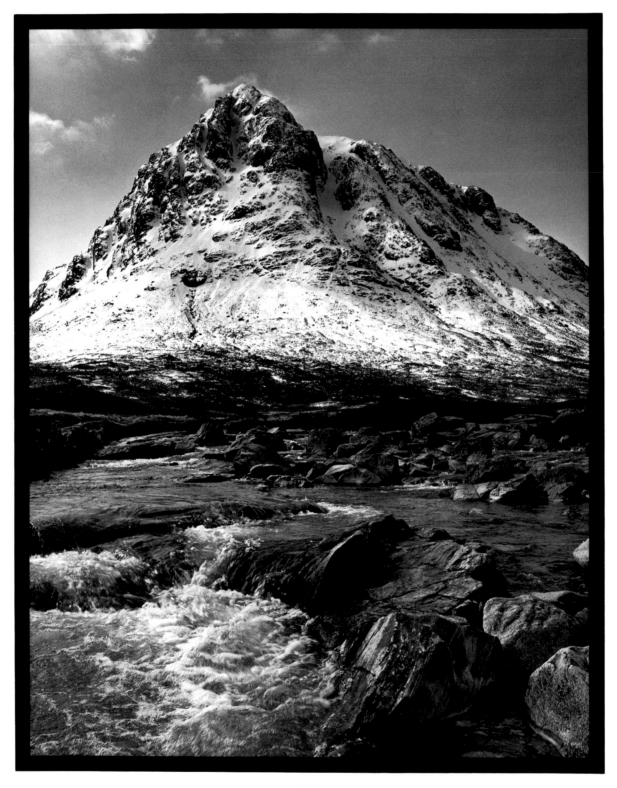

11
Buchaille Etive Mor
David Butcher

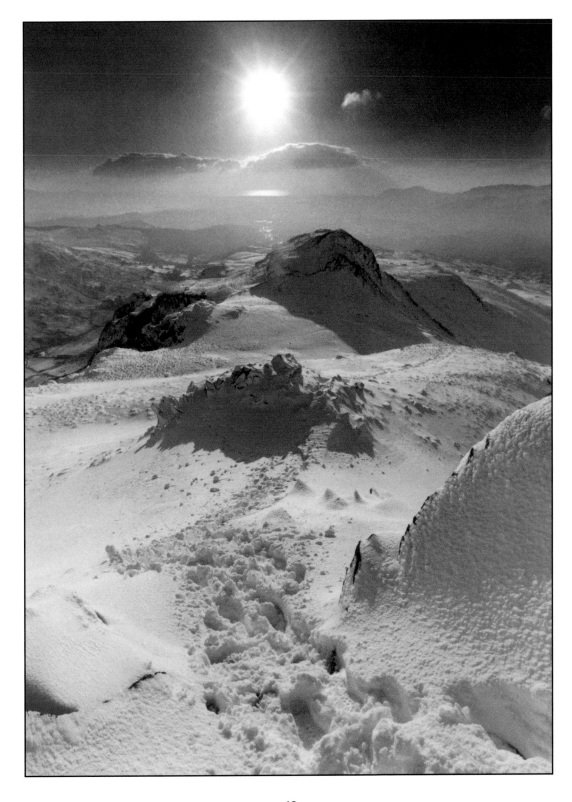

12
Eira
O Tudur Owen

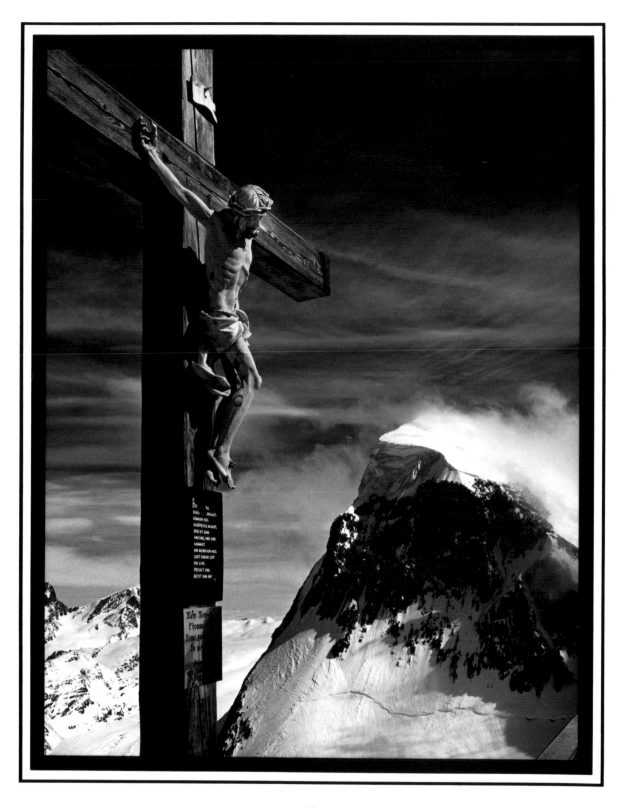

13
High mountain shrine and the Breithorn
David Butcher

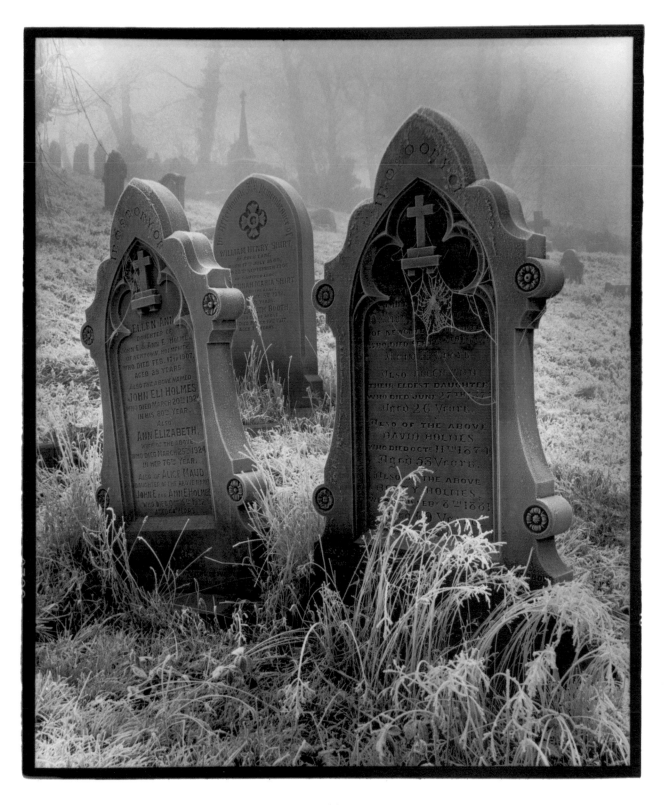

14
Frosty graves
Andrew Sanderson

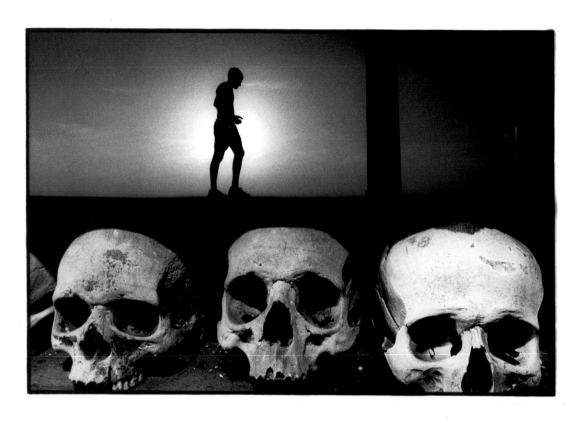

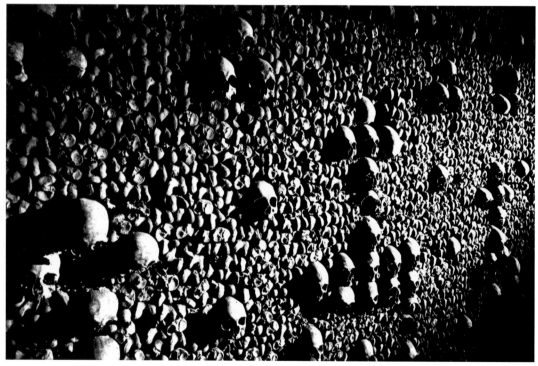

(top) 15 **Holocaust** *Steve Boyle*
(bottom) 16 **Catacomb passage** *Tyrone McDonald*

18

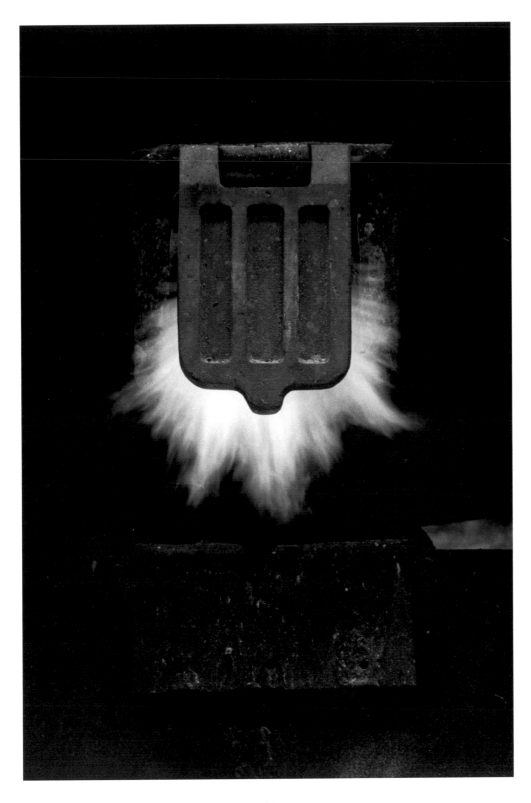

17
Furnace vent
Tom Keely

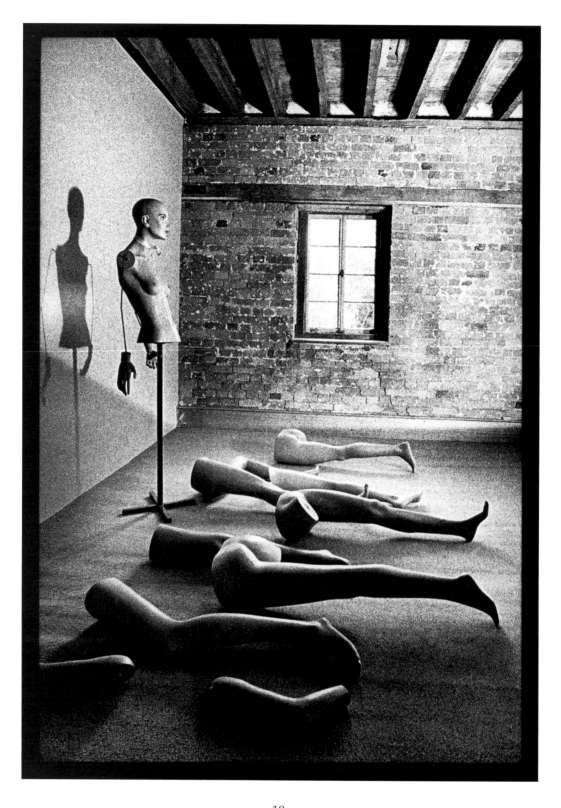

18
Legs
Peter Motton

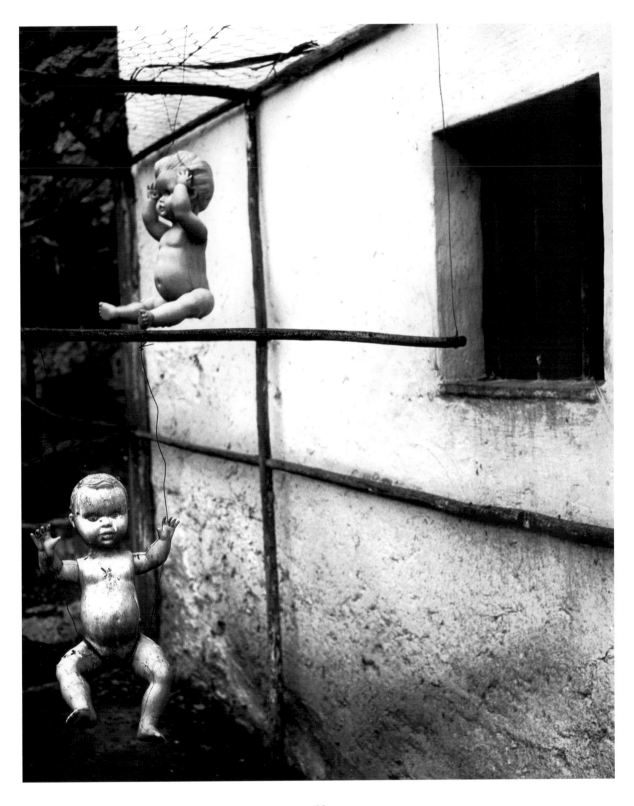

19
Dolls in captivity
Bill Carden

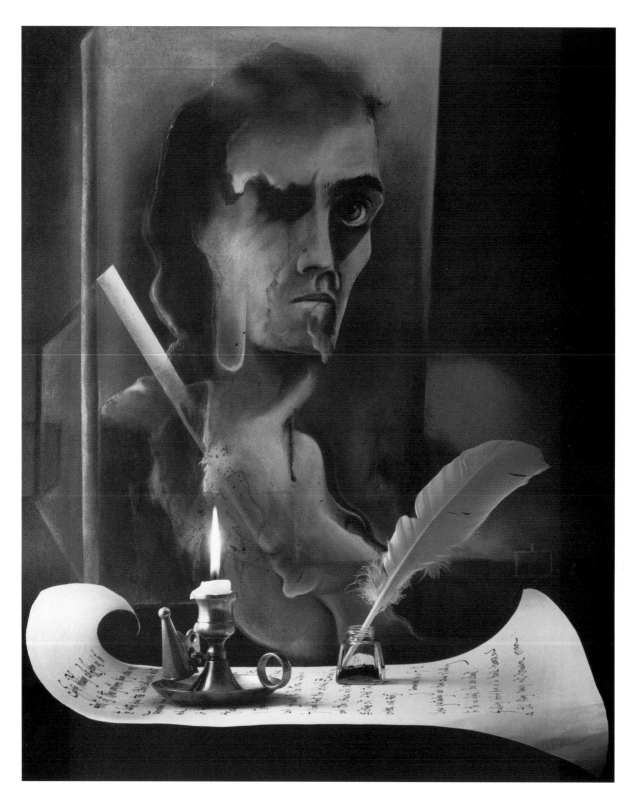

20
Dorian Gray (self portrait)
Pat Canavan

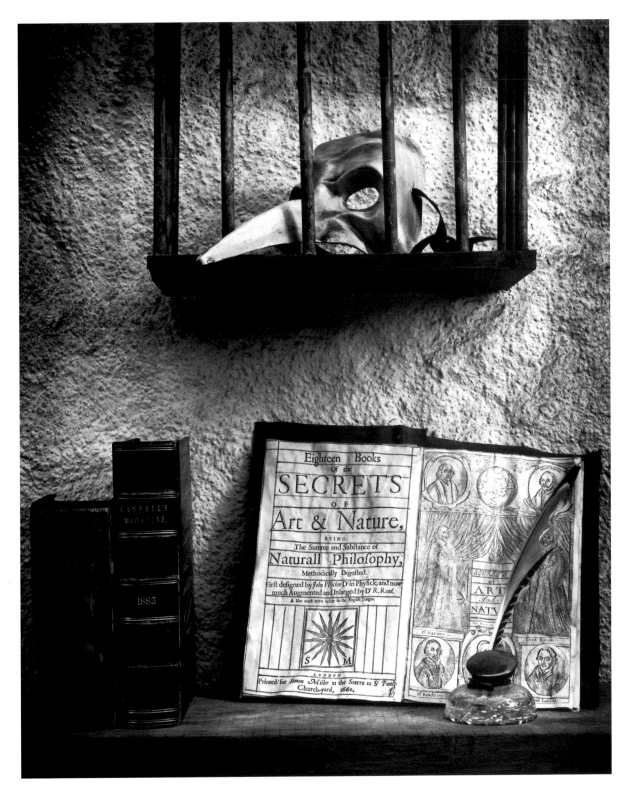

21
Secrets of art and nature
Paul Warner

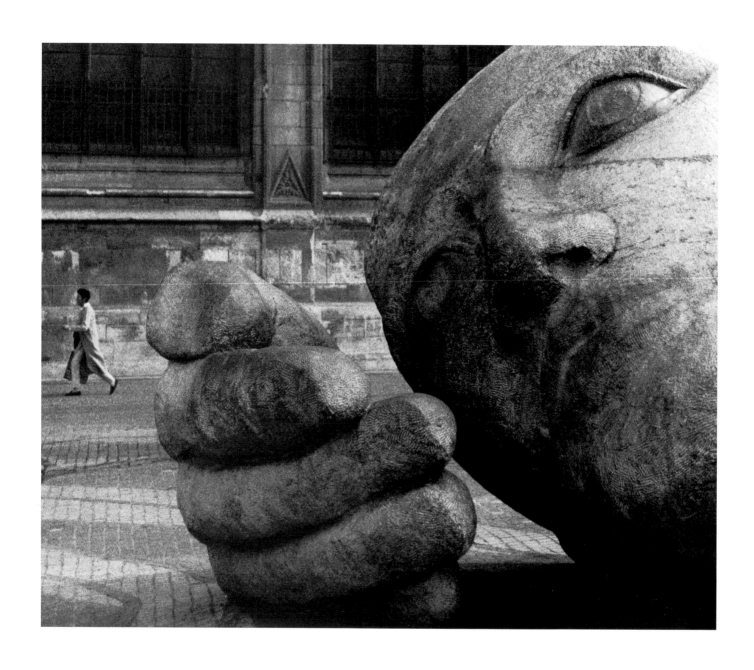

22
Larger than life
Alan Brown (Tyne & Wear)

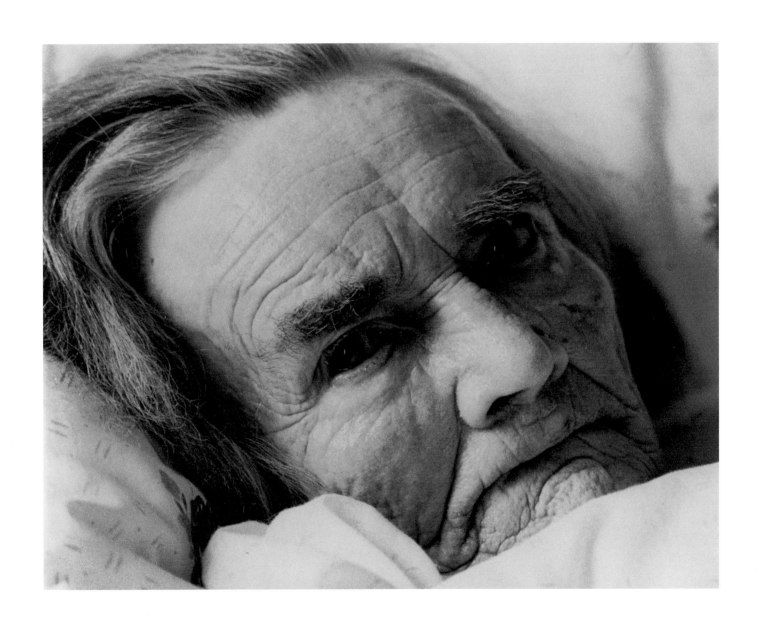

23
Madeline
Catharine Willerton

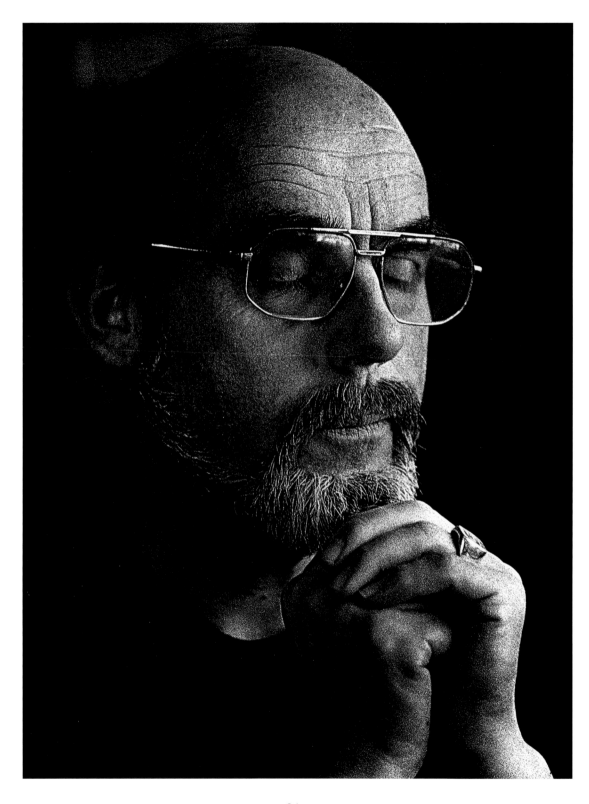

24
Meditation
Signe Drevsjø

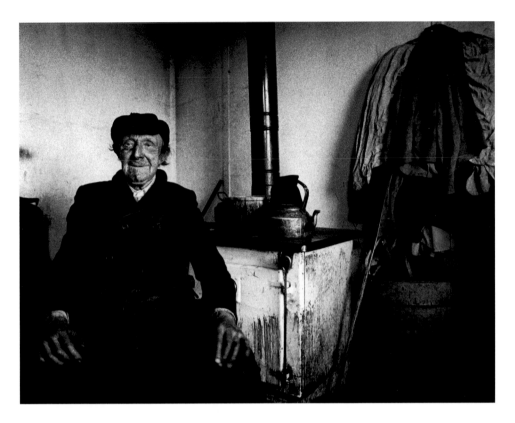

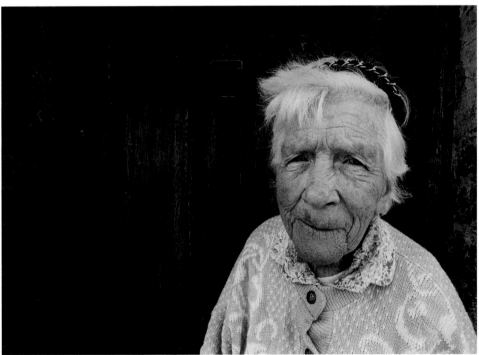

(top) 25 **Ben** *Des Clinton*
(bottom) 26 **Kathleen, Drogheda** *Leigh Preston*

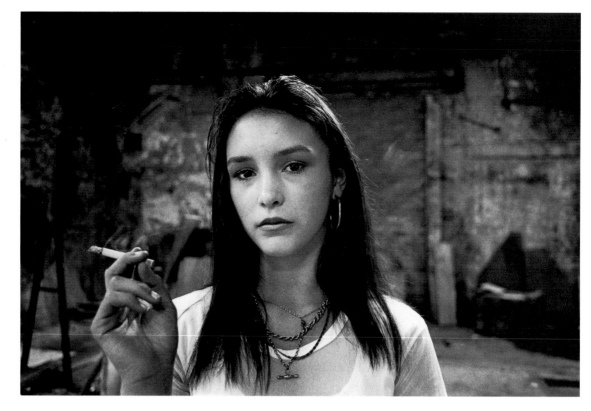

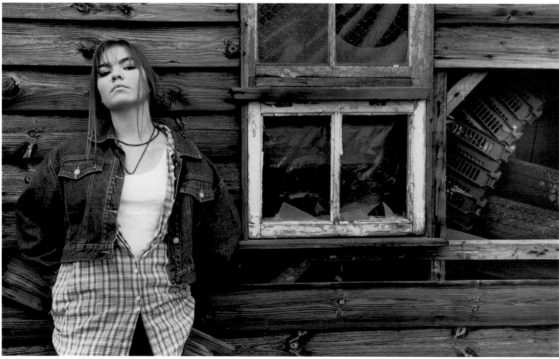

(top) 27 **Birmingham girl** *Leigh Preston*
(bottom) 28 **Clare** *Peter Holzapfel*

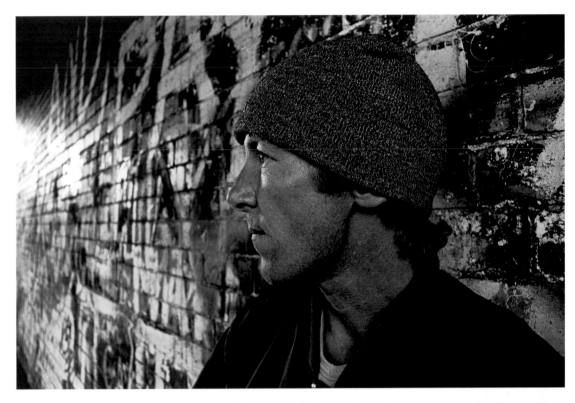

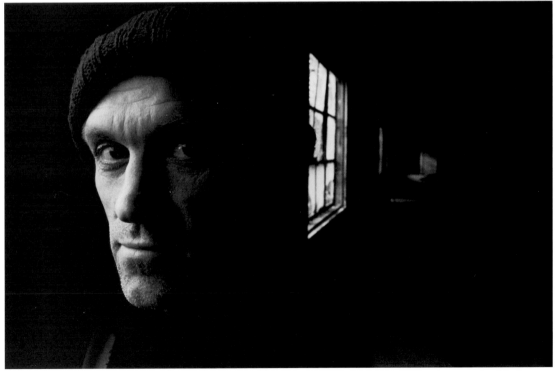

(top) 29 **Untitled** *Claire Holliday*
(bottom) 30 **Rob** *Gary Phillips*

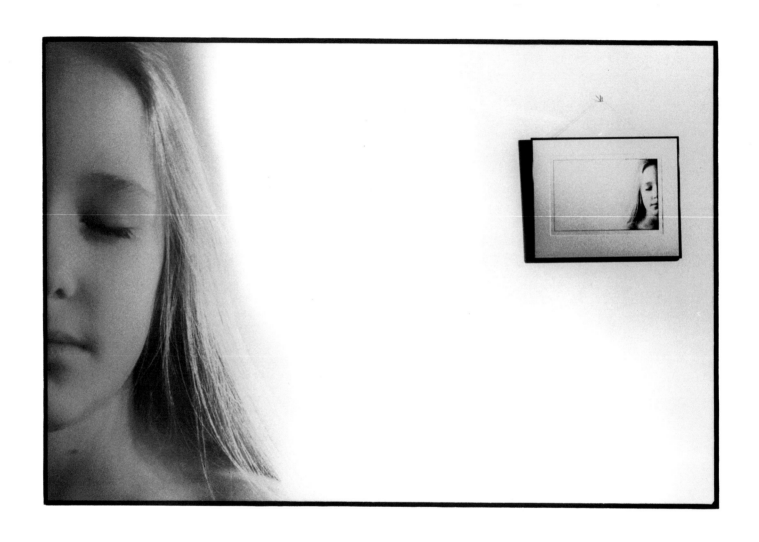

31
Face on the wall
Steve Boyle

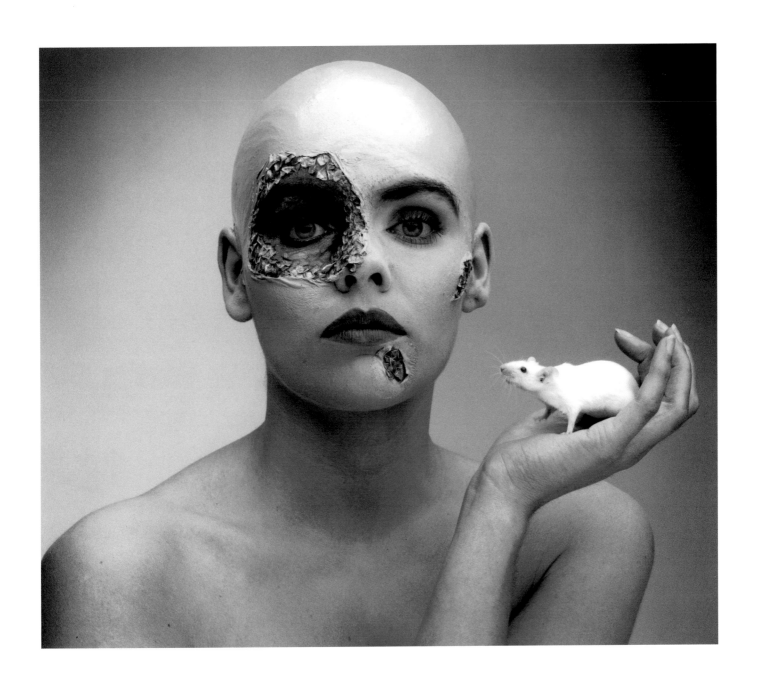

32
Mister Mouse's worst nightmare
Trevor Legate

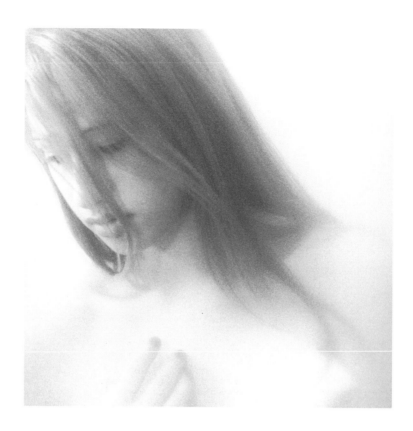

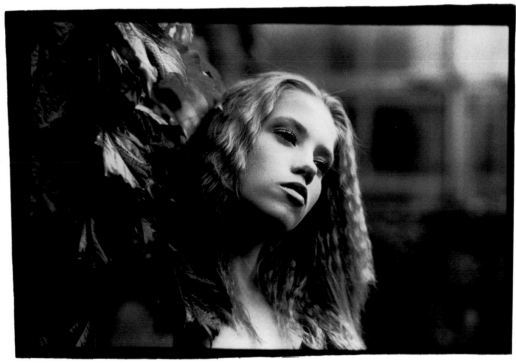

(top) 33 **Natalie** *Priscilla Thomas*
(bottom) 34 **Dreamer** *Martin Mordecai*

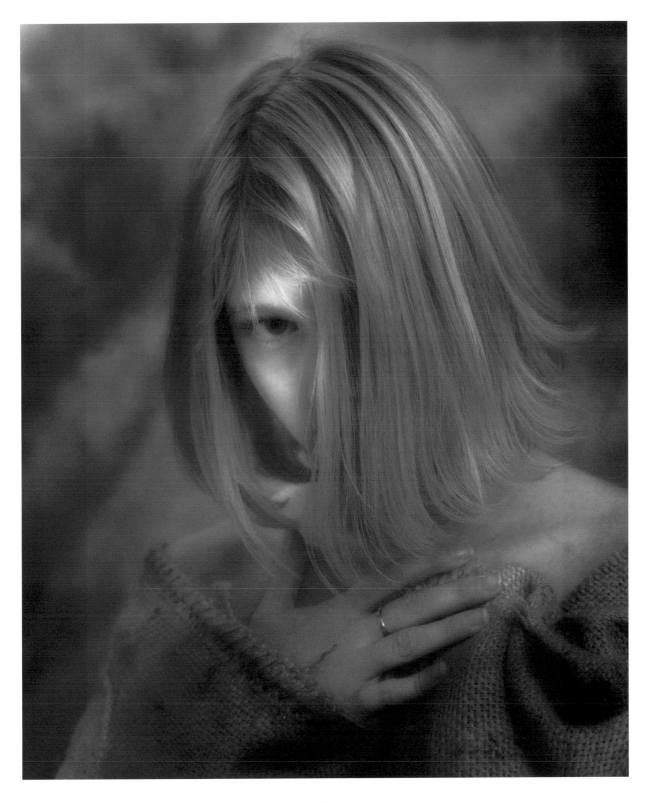

35
Nikki IV
Cleif Roberts

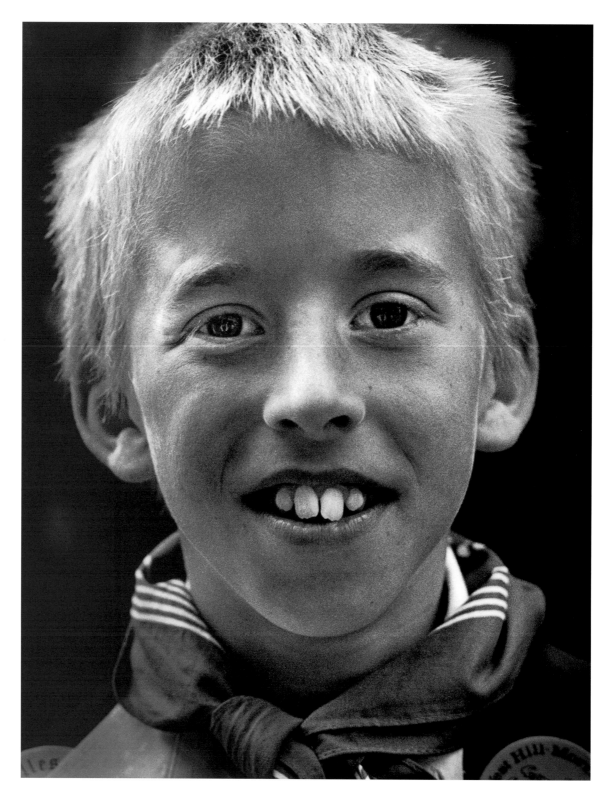

36
Morris boy
Clive Harrison

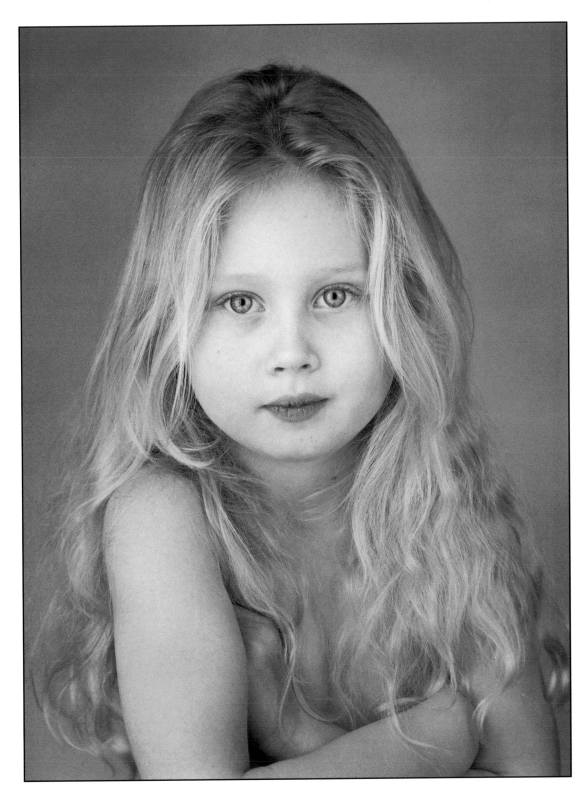

37
Kerry
Gerry Coe

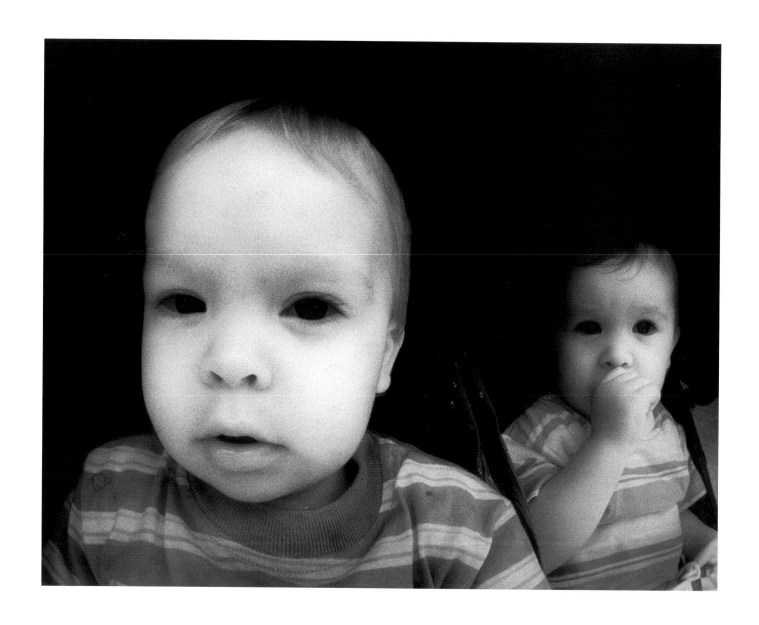

38
Twins II
Colin Snelson

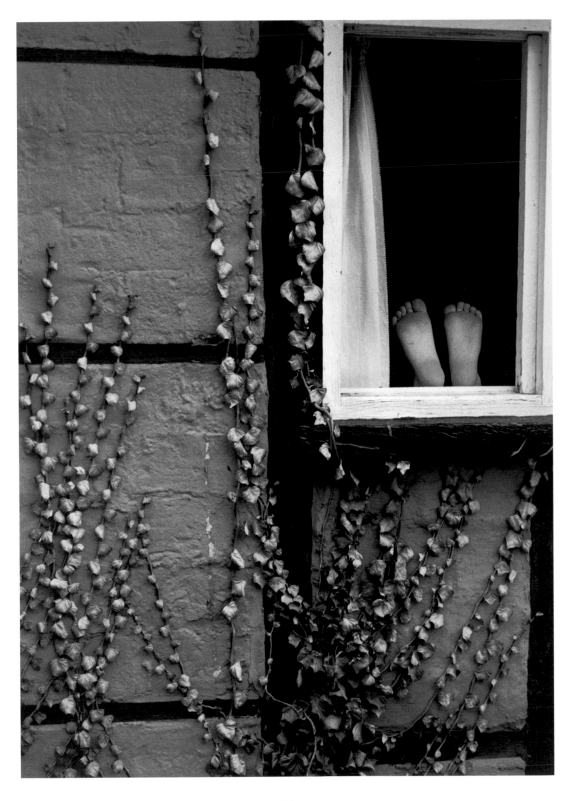

39
Kate's feet
Mary Davis

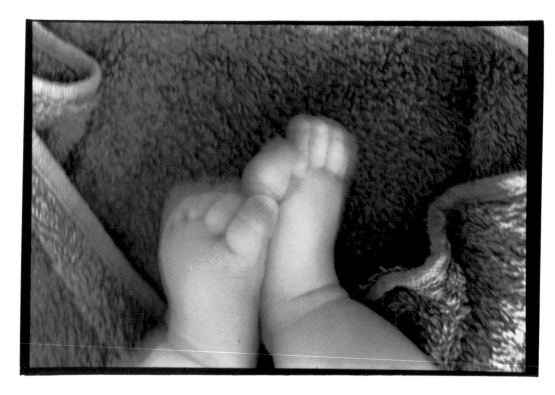

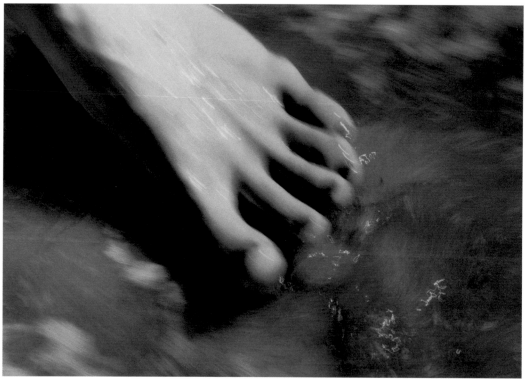

(top) 40 **Baby feet** *Paul Hensey*
(bottom) 41 **Untitled** *Lesley-Anne Deaves*

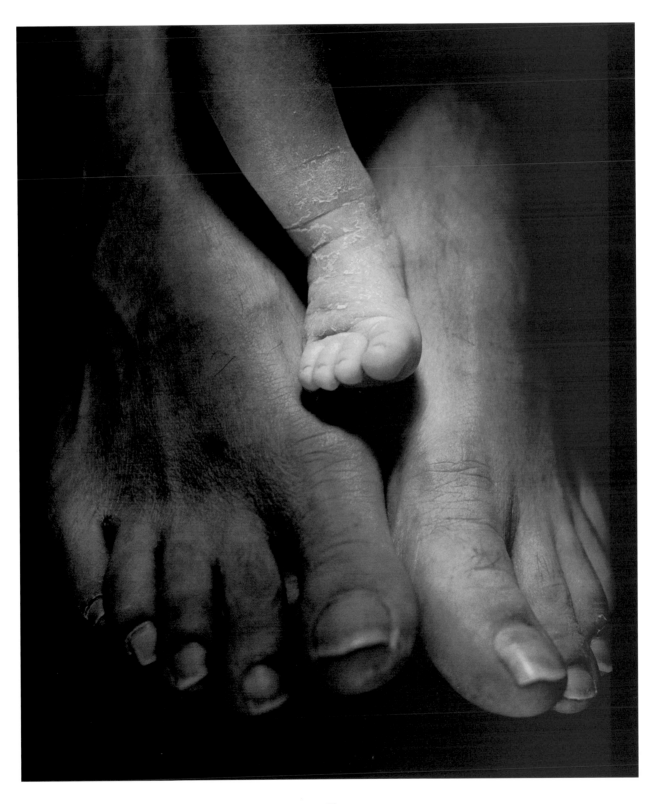

42
One week old
Andrew Sanderson

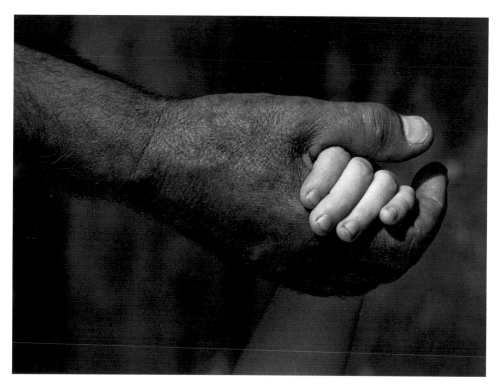

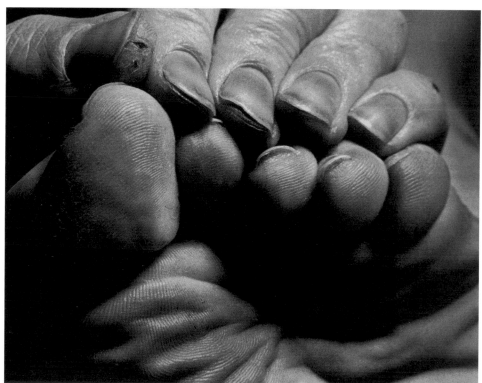

(top) 43 **Grand-daughter** *Roger Slade*
(bottom) 44 **Fingers and toes** *Andrew Sanderson*

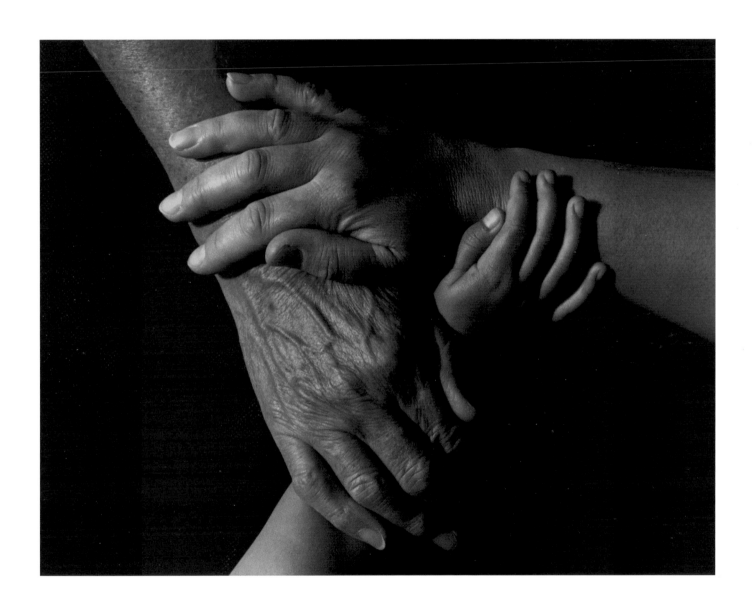

45
Handed down the generations
David Dunning

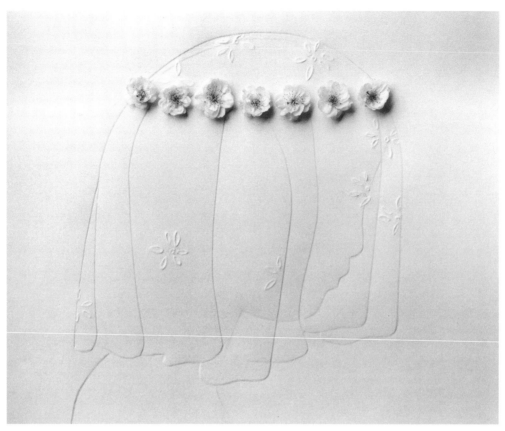

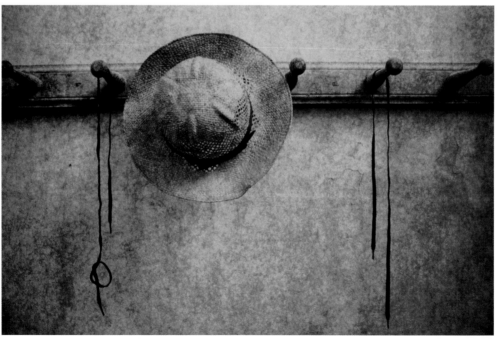

(top) 46 **The veil** *Christine Chambers*
(bottom) 47 **Summer hat** *Den Reader*

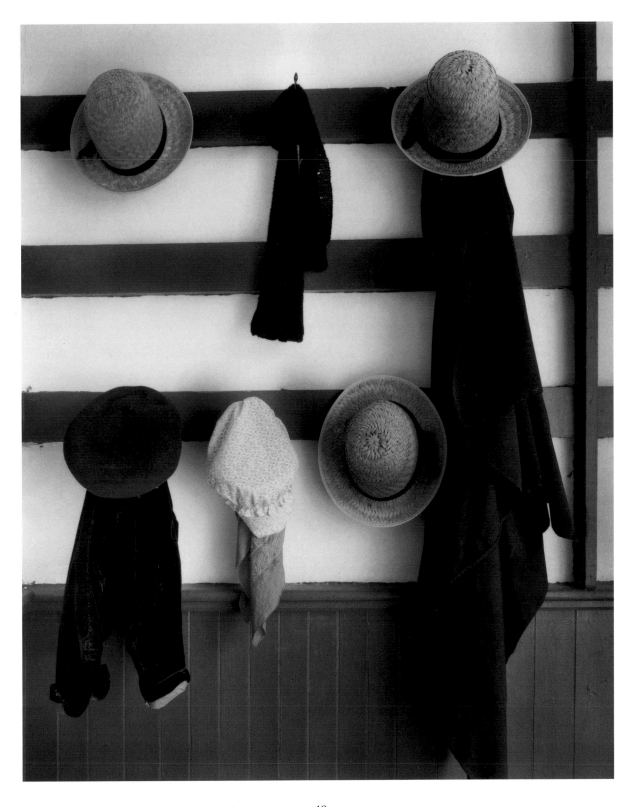

48
Vestibule
Clarence Carvell

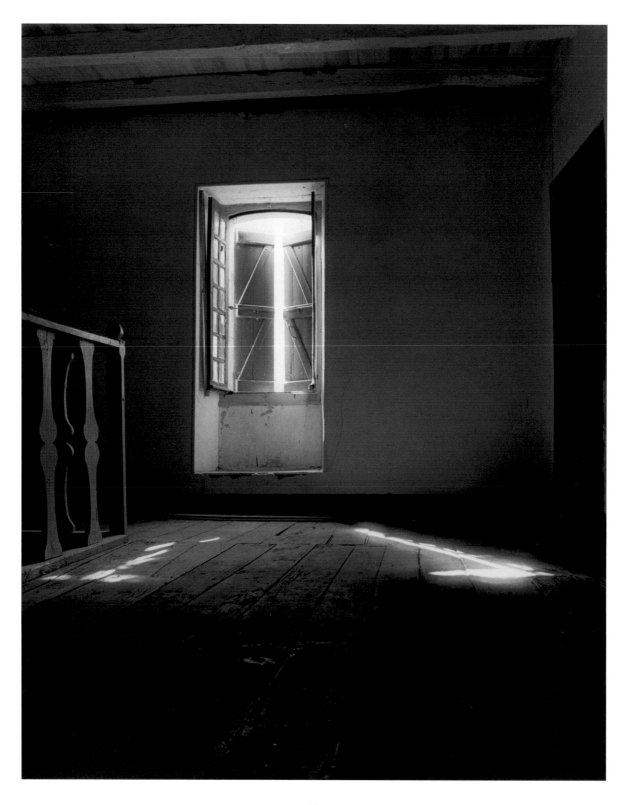

49
Saux 1997: L'étage
John Seely

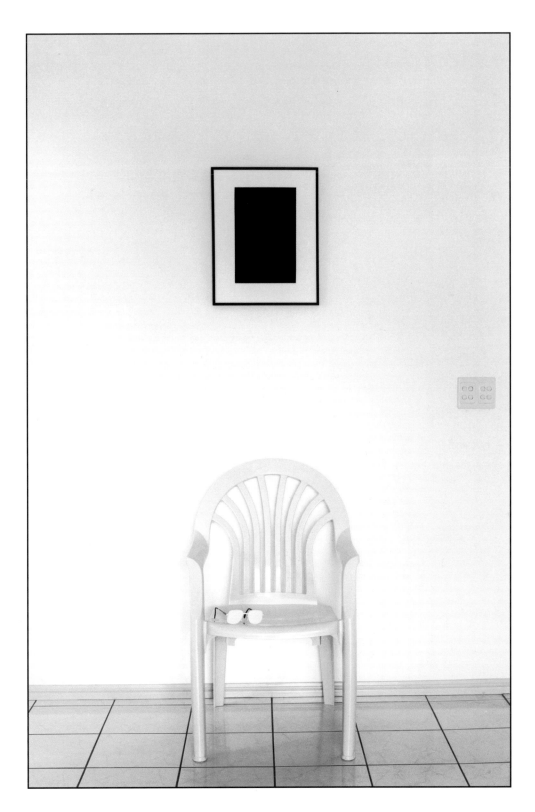

50
Deprivation
Fred Hunt

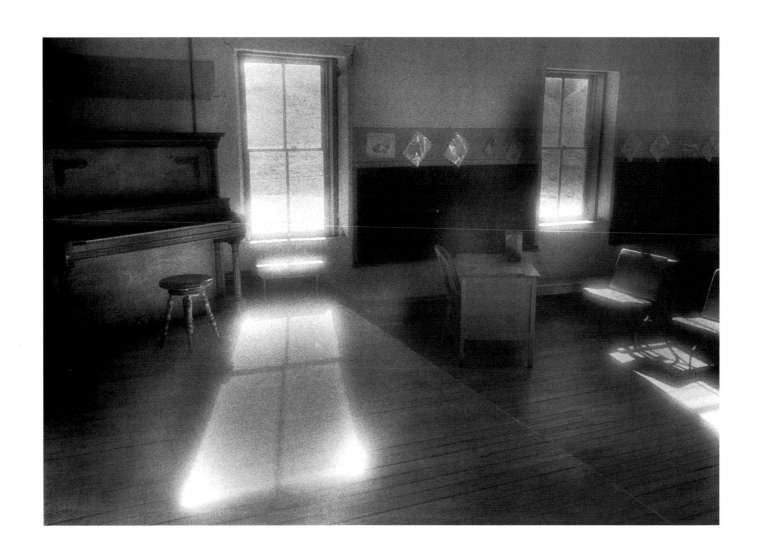

51
The schoolroom
Carolyn Bross

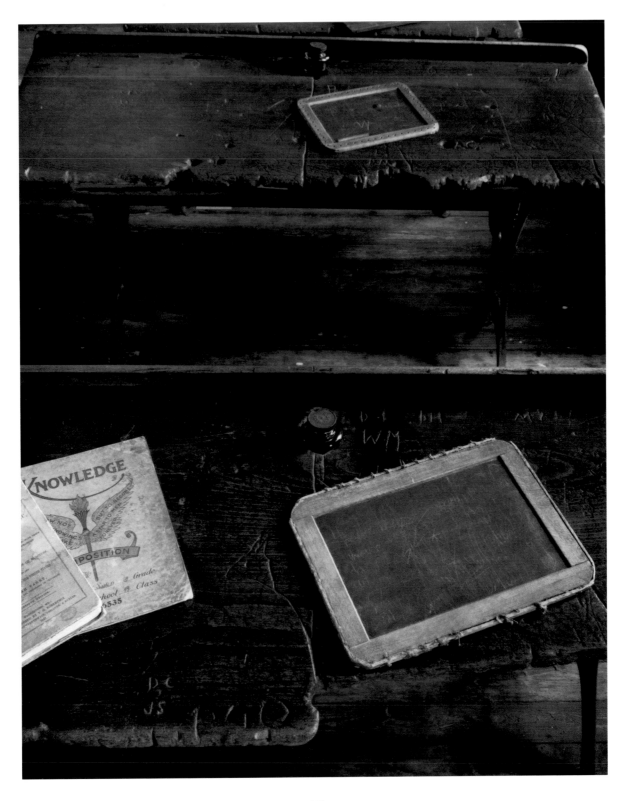

52
Rural education
Clarence Carvell

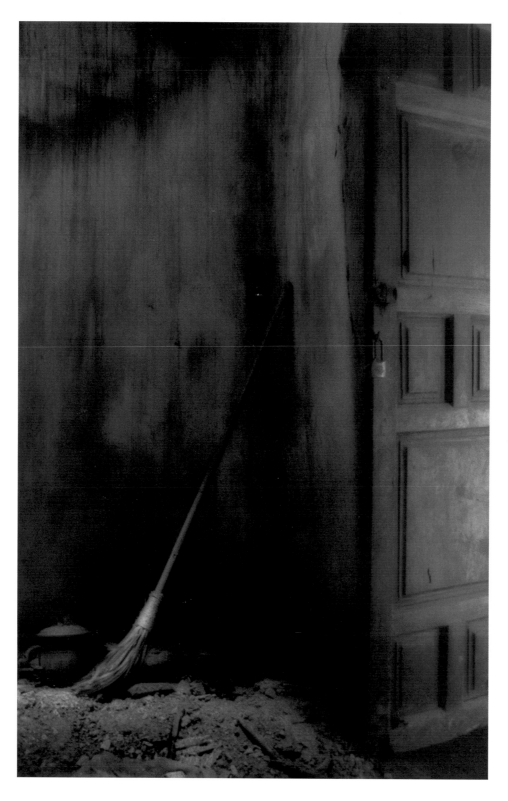

53
Andalucia, Spain
Lesley-Anne Deaves

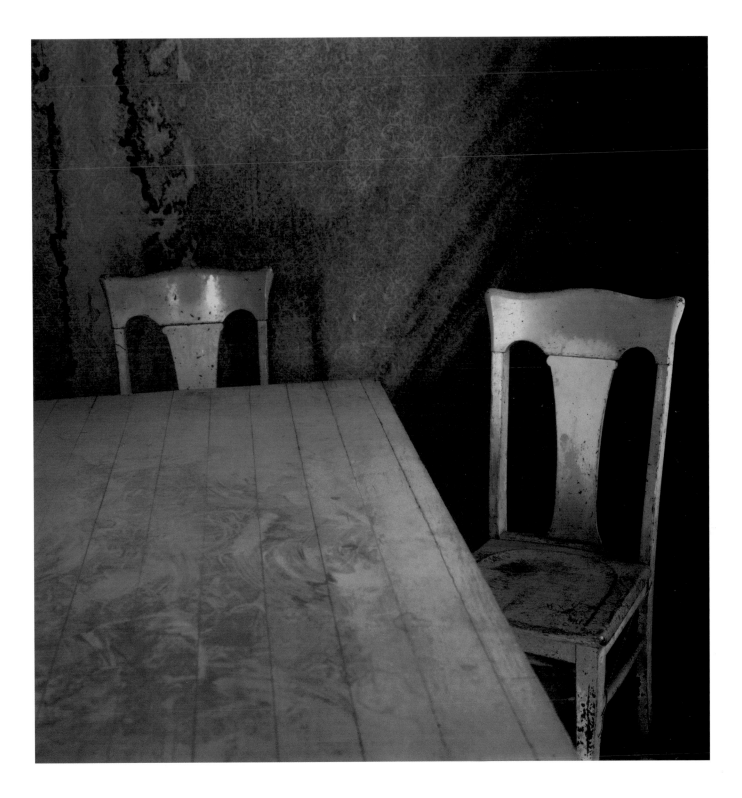

54
Sometimes I sit and talk
Clarence Carvell

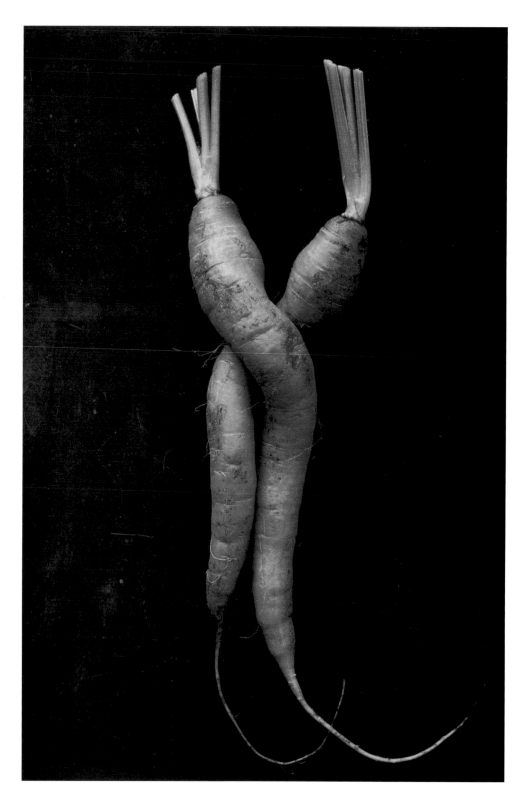

55
Carrots entwined
Den Reader

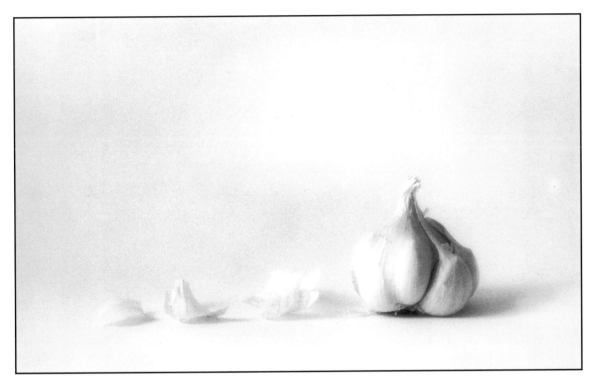

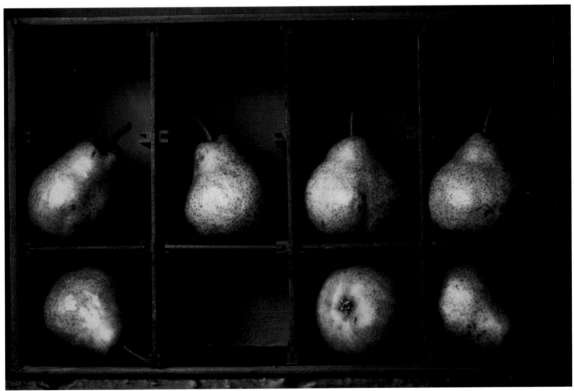

(top) 56 **Garlic** *Steve Zalokoski*
(bottom) 57 **Seven pears** *Den Reader*

51

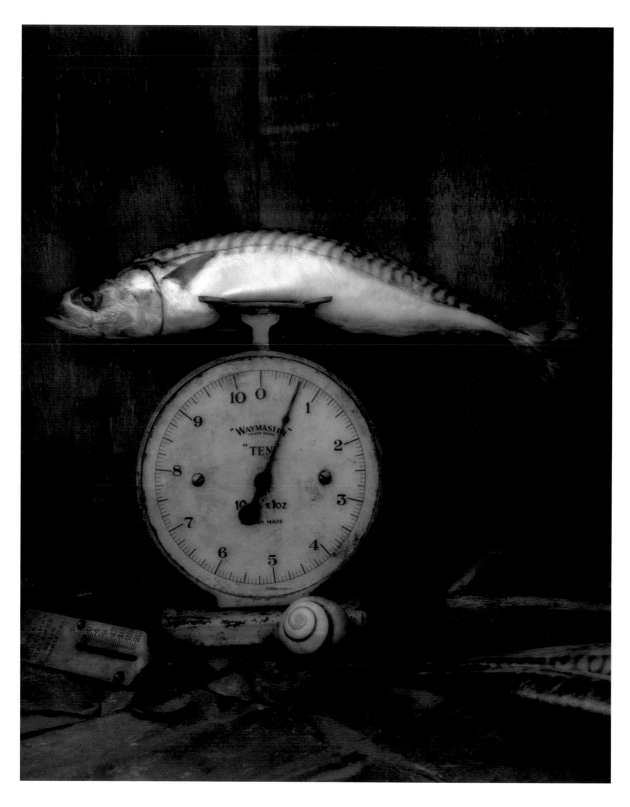

58
Scales
Lesley Thoburn

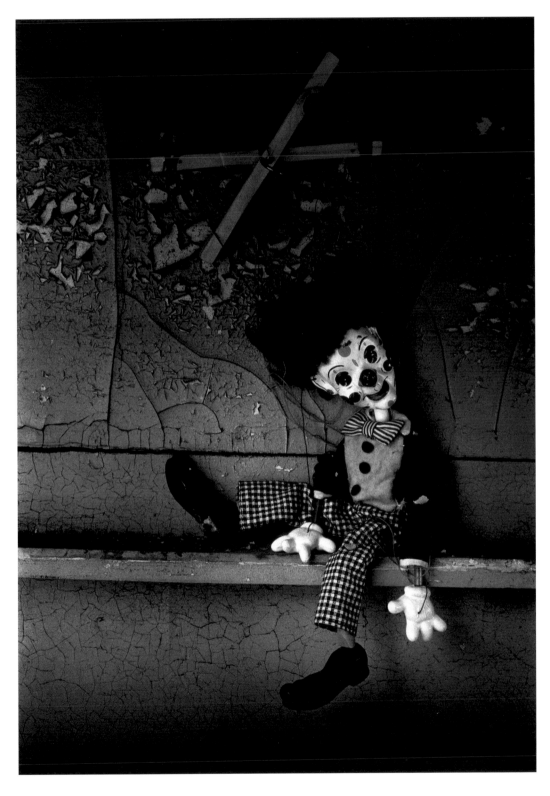

59
Left on the shelf
Lesley Thoburn

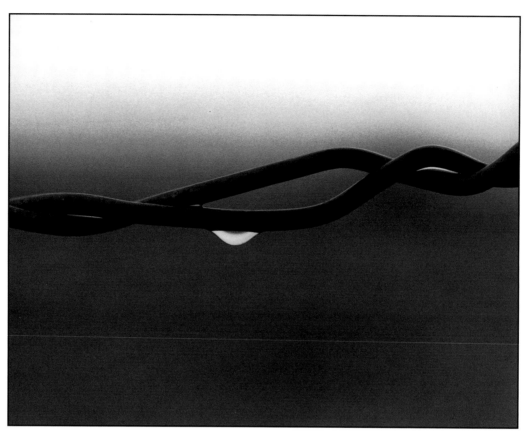

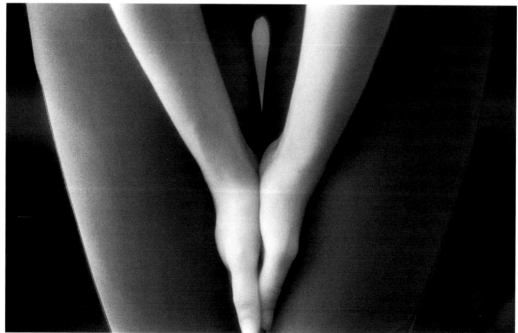

(top) 60 **Rain drop on wire** *Gill King*
(bottom) 61 **Féminité** *Denis Bourg*

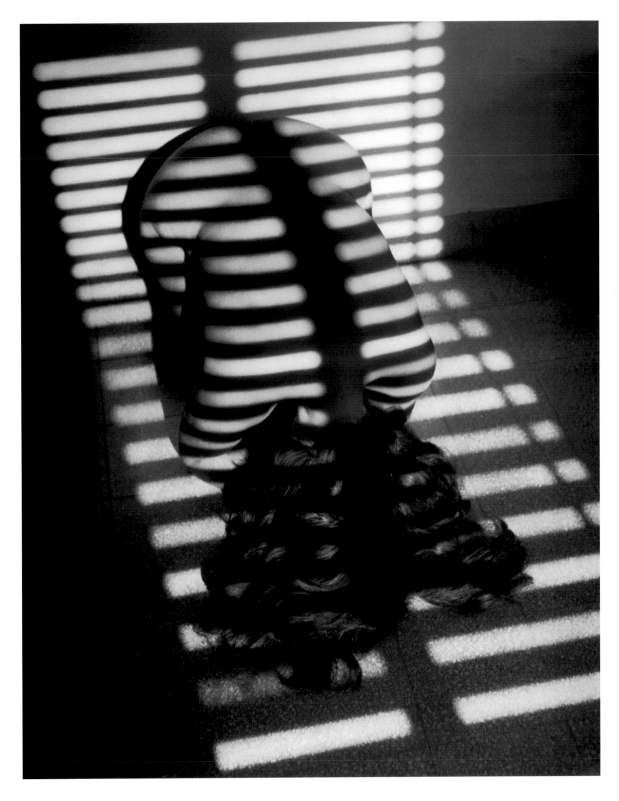

62
Spinal column
Reuven Milon

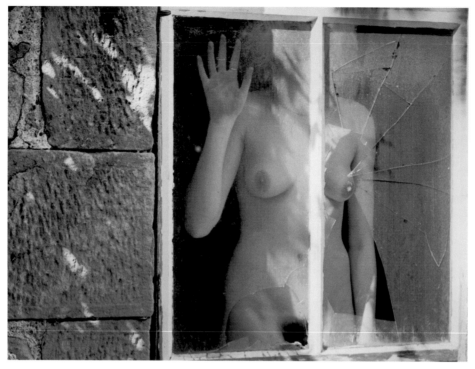

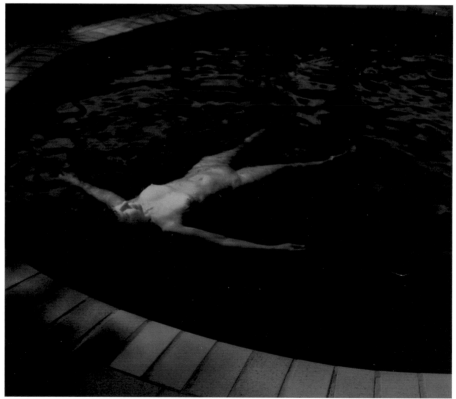

(top) 63 **At the window** *Roy Elwood*
(bottom) 64 **Floating in the dark pool** *Derek Christy*

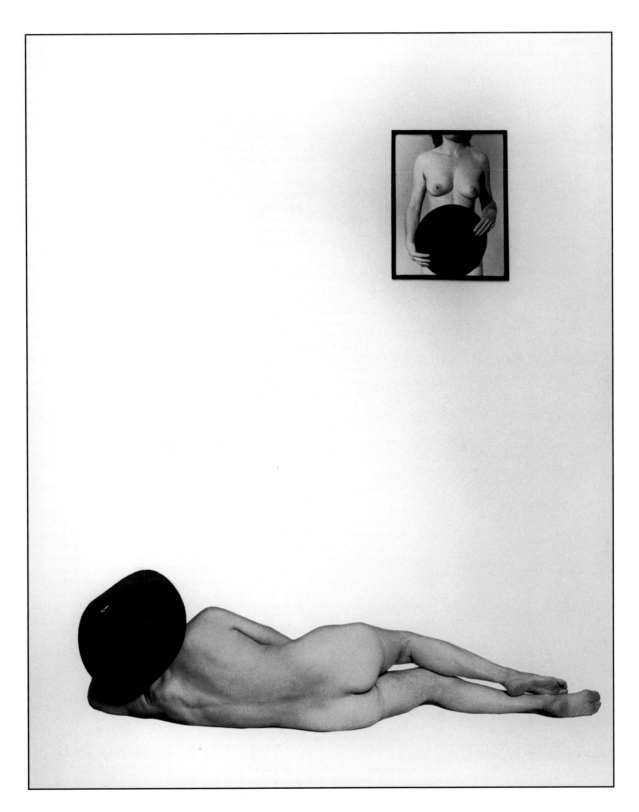

65
Untitled
Roy Elwood

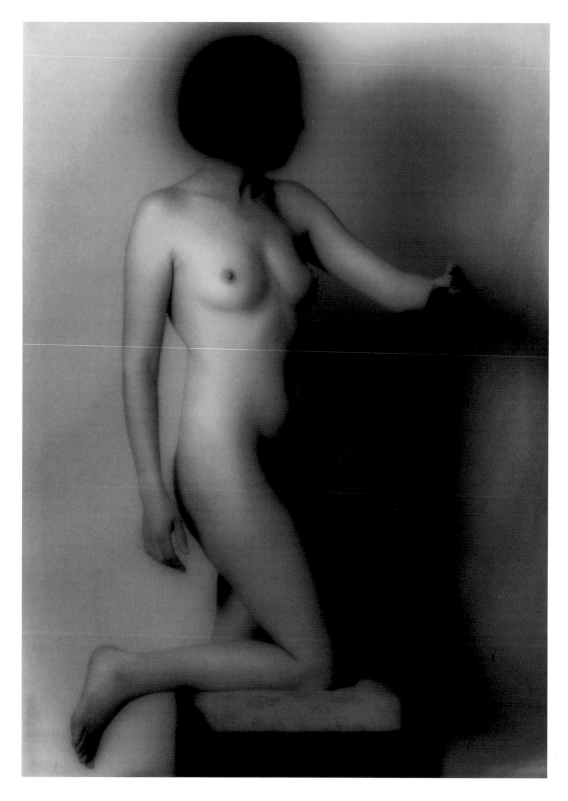

66
Figure 2
Phil Hartley

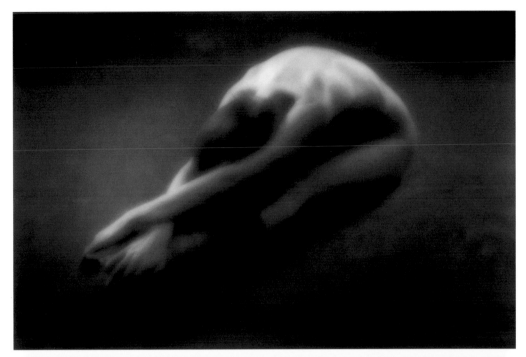

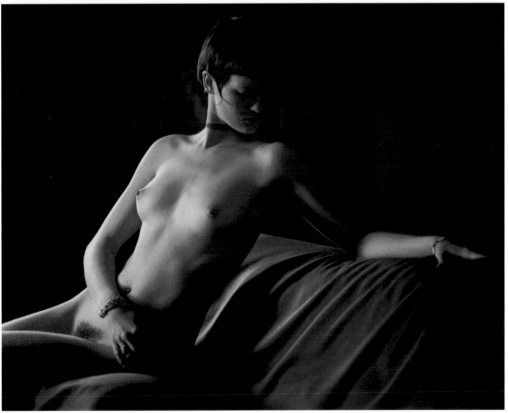

(top) 67 **Figure study #3** *Brian Harvey*
(bottom) 68 **Kay resting** *Derek Christy*

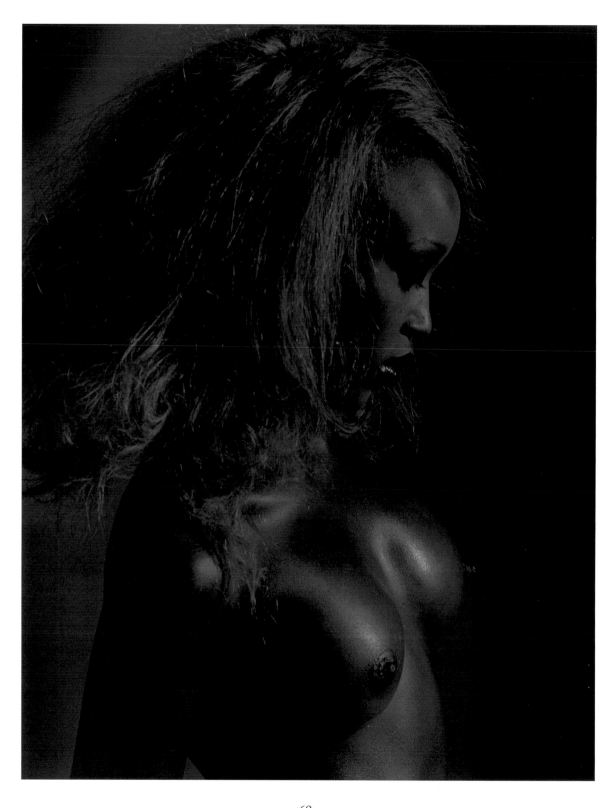

69
Foxy
Hugh Spence

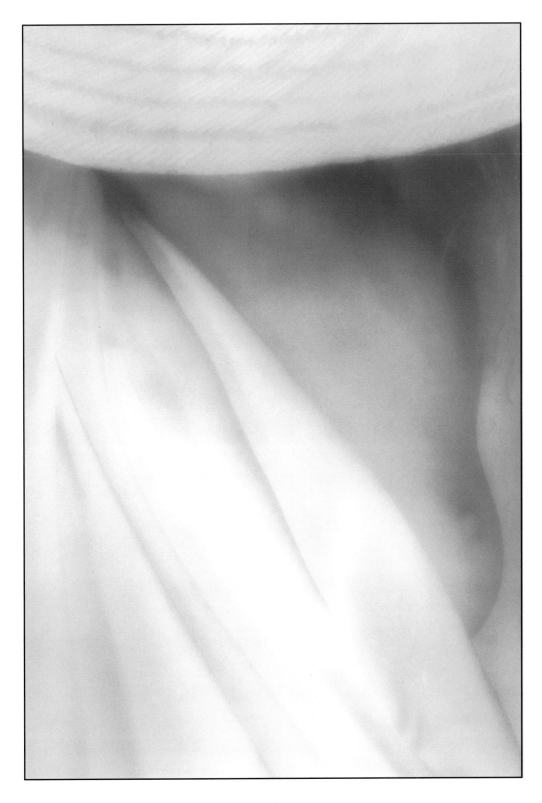

70
Curves
Gary Phillips

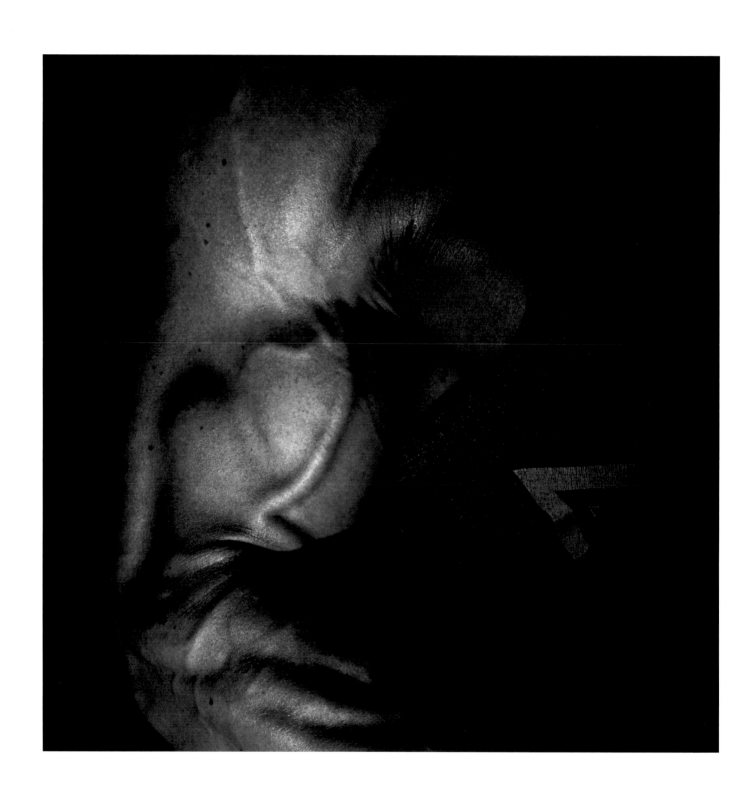

71
Muskel
Rolf Raucheis

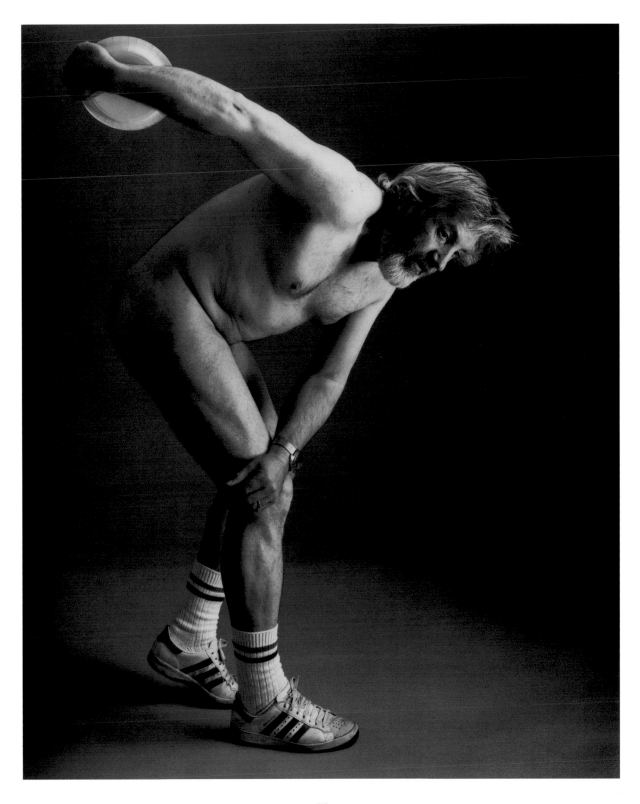

72
Parody
Roger Wilson

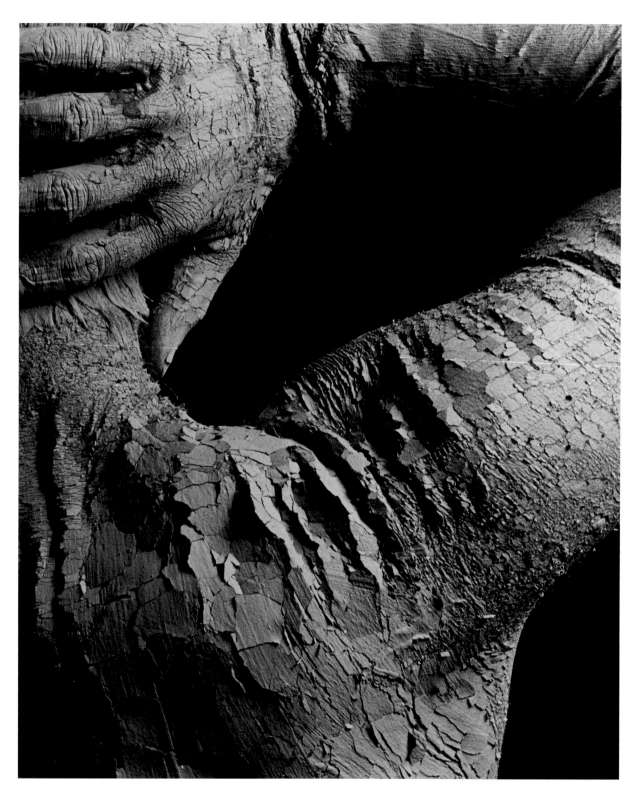

73
Untitled #3
Claire Holliday

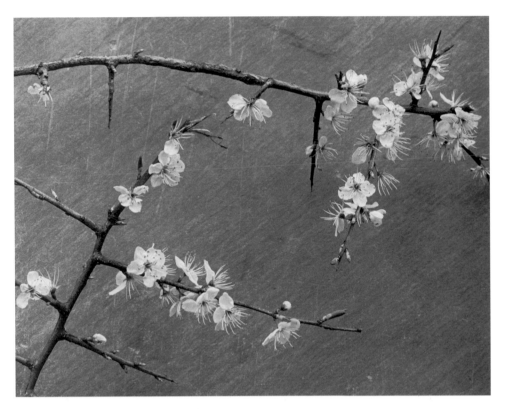

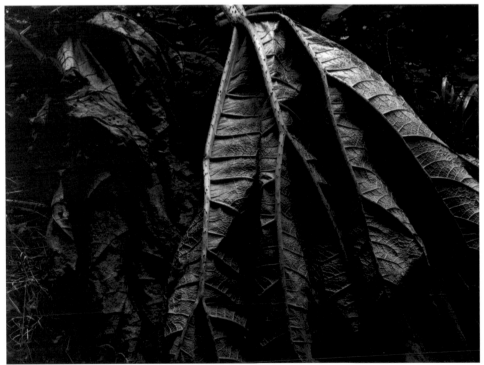

(top) 74 **Blackthorn blossom** *Gill King*
(bottom) 75 **Gunnera** *Kerry Glasier*

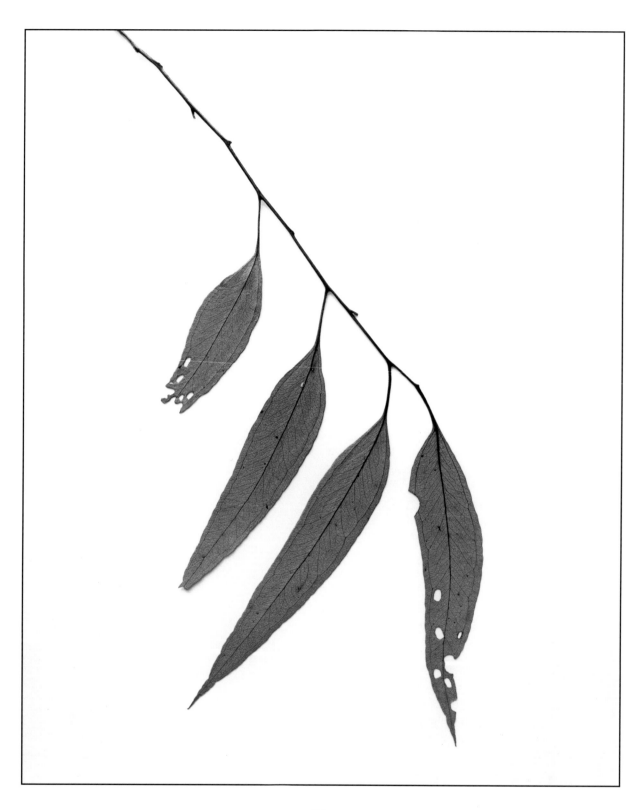

76
Four gum leaves
Fred Hunt

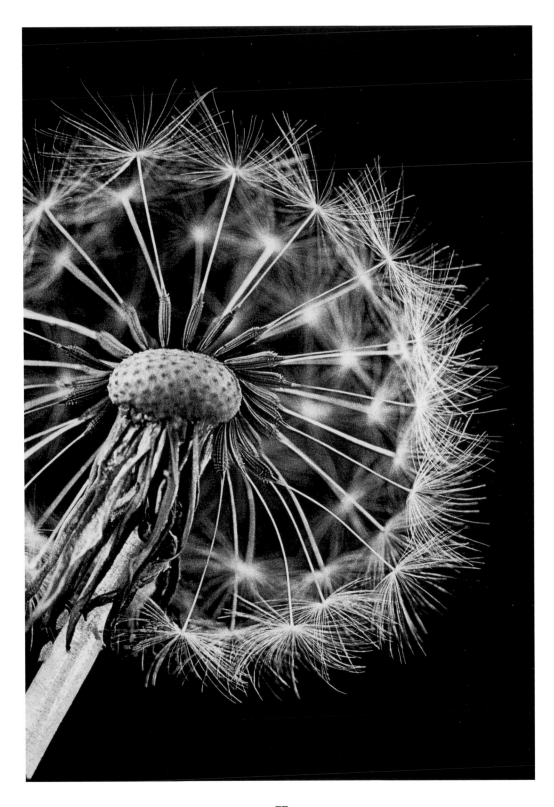

77
Dandelion
Peter Motton

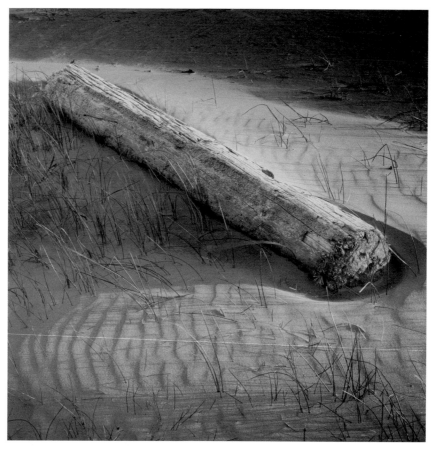

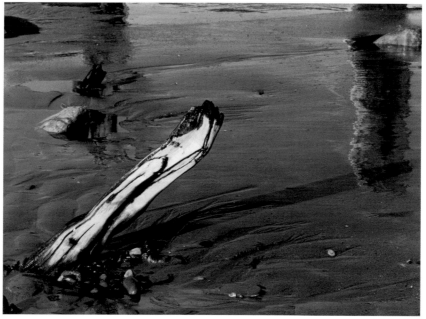

(top) 78 **With the evening tide** *Kevin Bridgwood*
(bottom) 79 **Bleached** *Neil Souch*

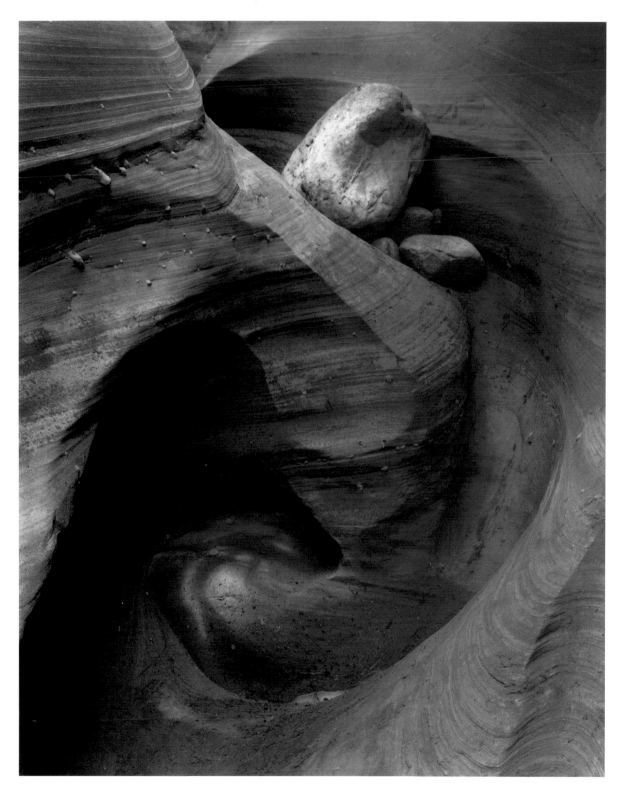

80
Waterhole Canyon, Arizona
Don Breakey

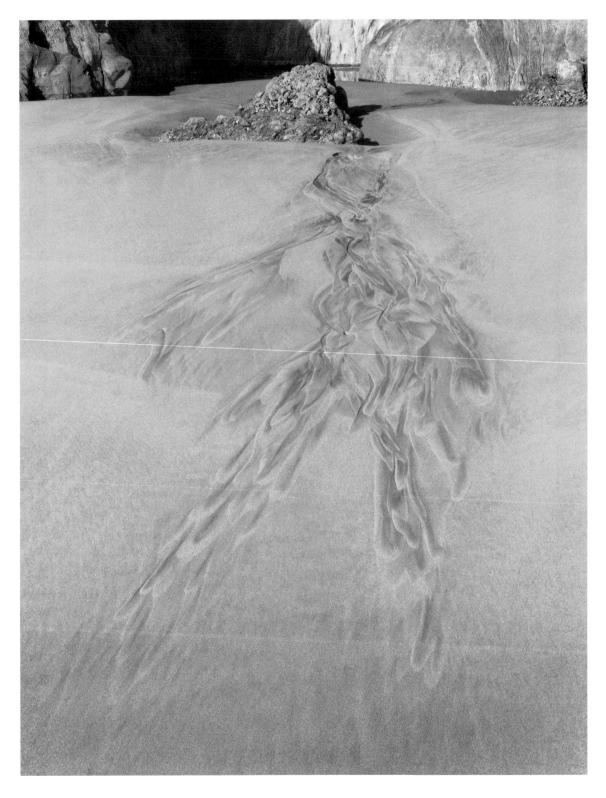

81
The Sand-Man
Trevor Crone

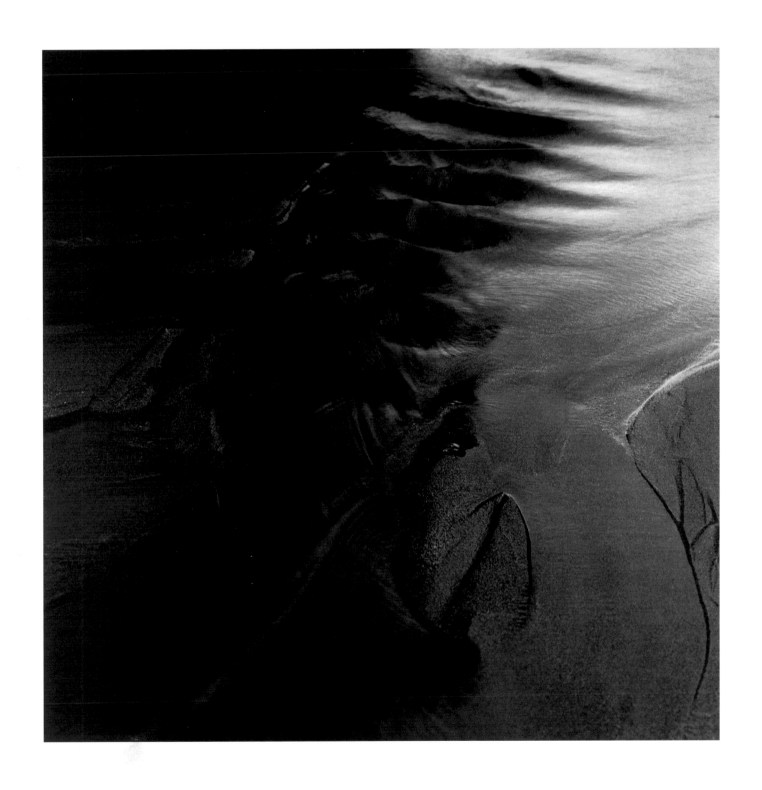

82
Beach torso
Roger Maile

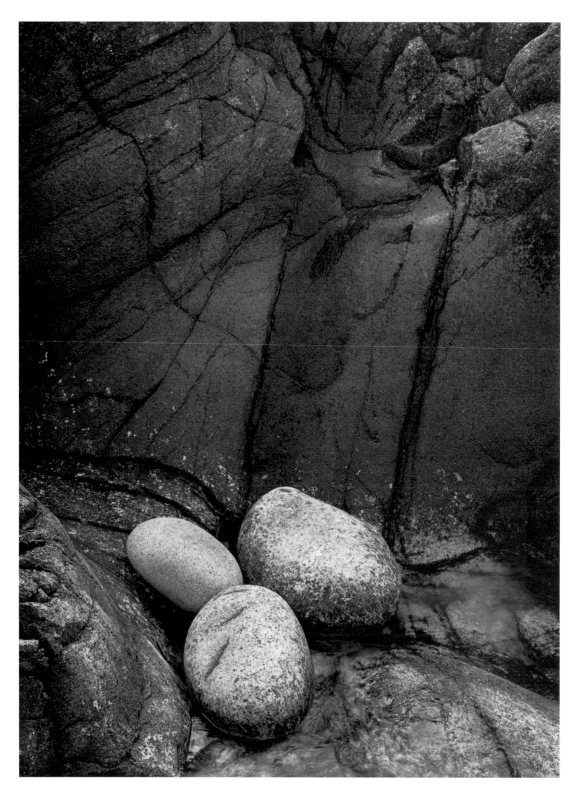

83
Cot Valley #3
Neil Souch

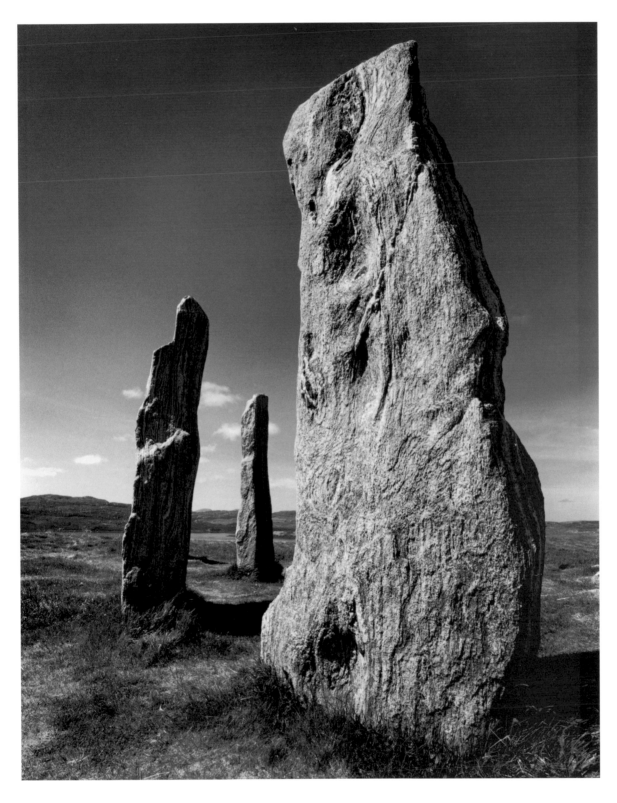

84
Callanish
Steve Terry

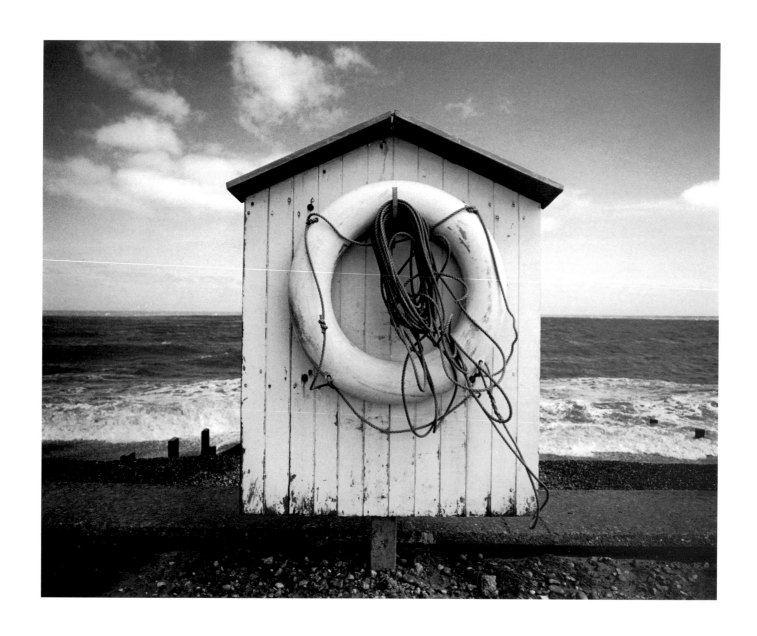

85
Untitled
Steve Garratt

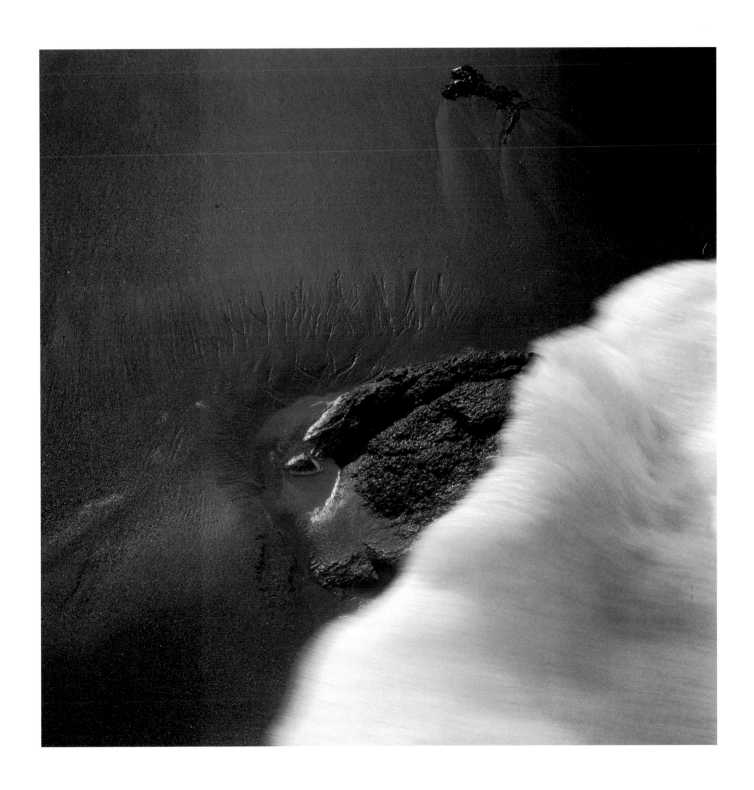

86
No title
Paul Booth

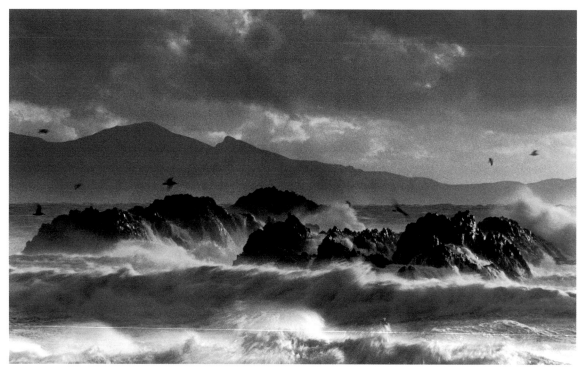

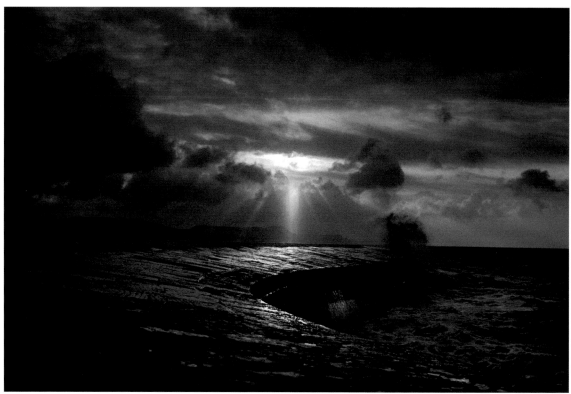

(top) 87 **Menai storm** *Gary Phillips*
(bottom) 88 **The Cobb, Lyme Regis** *Steve Garratt*

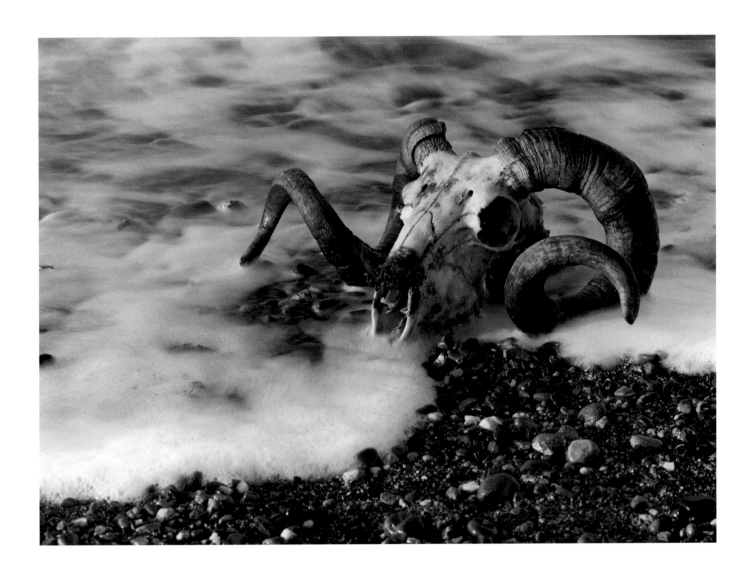

89
Y Môr Marw (The Dead Sea)
Cleif Roberts

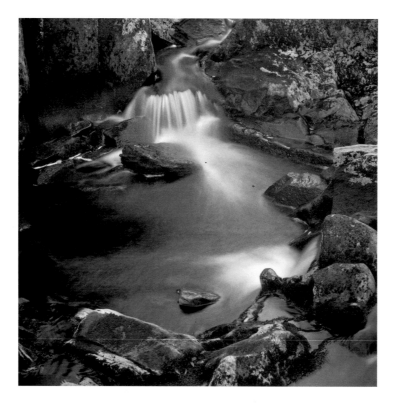

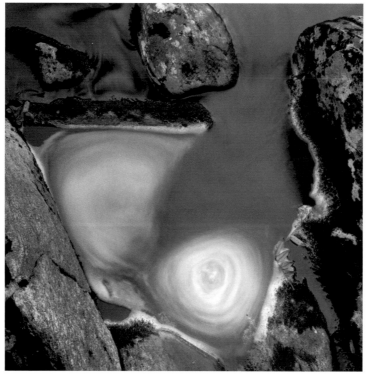

(top) 90 **Rocks and water, Glengarry** *Stewart Prince*
(bottom) 91 **Eddy pattern** *Stewart Prince*

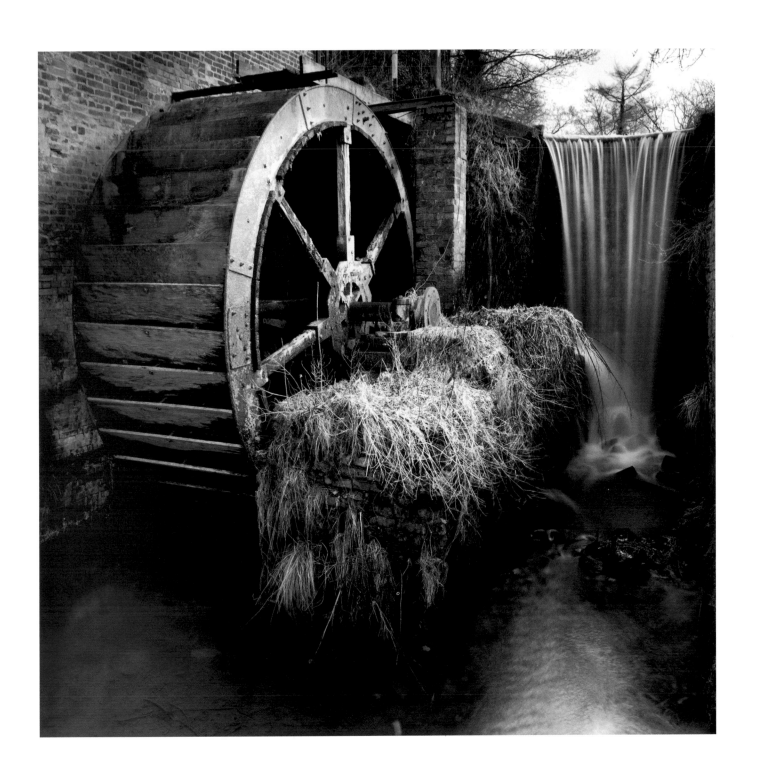

92
No title
Kevin Bridgwood

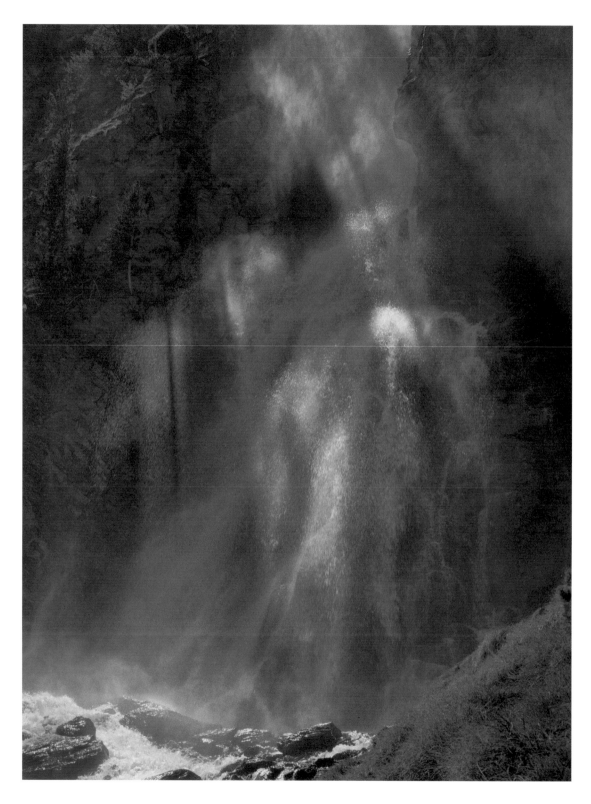

93
Cascade de la Pisse
Bob Marshall

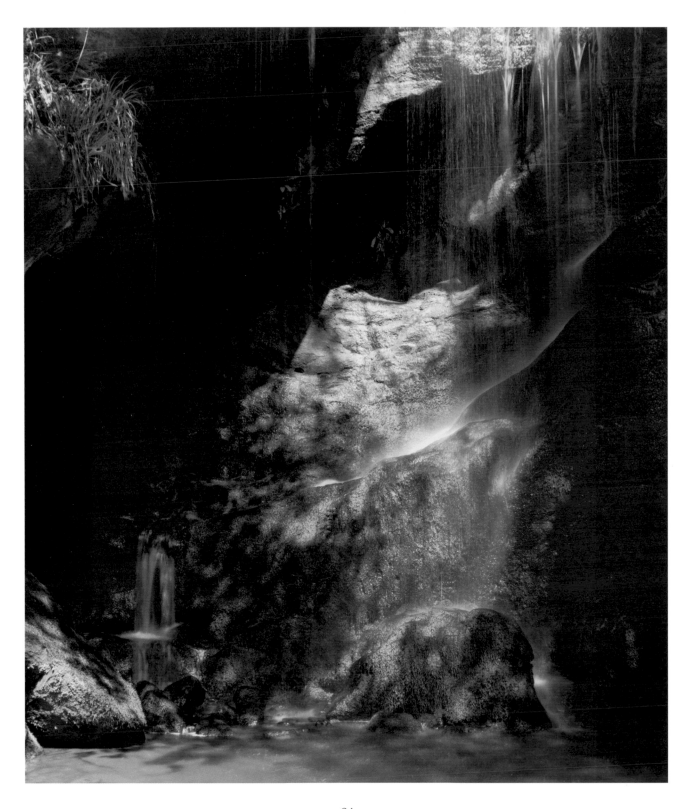

94
Roughting Linn
Michael Colley

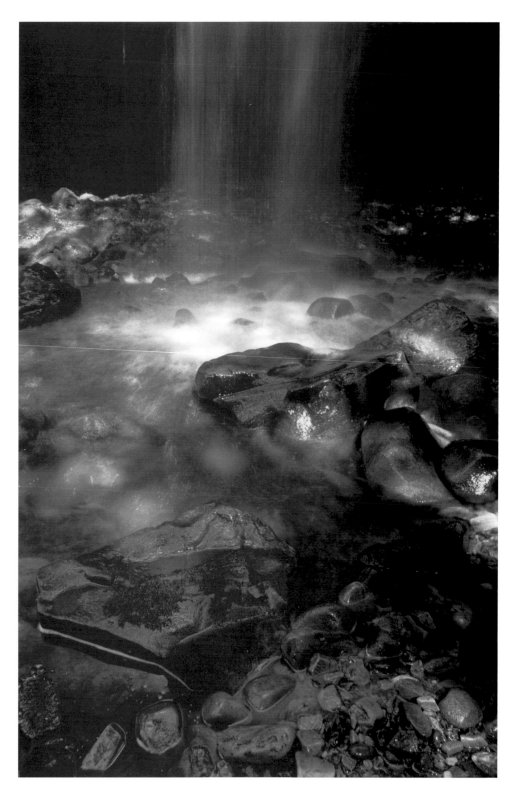

95
Fall's end
Michael Calder

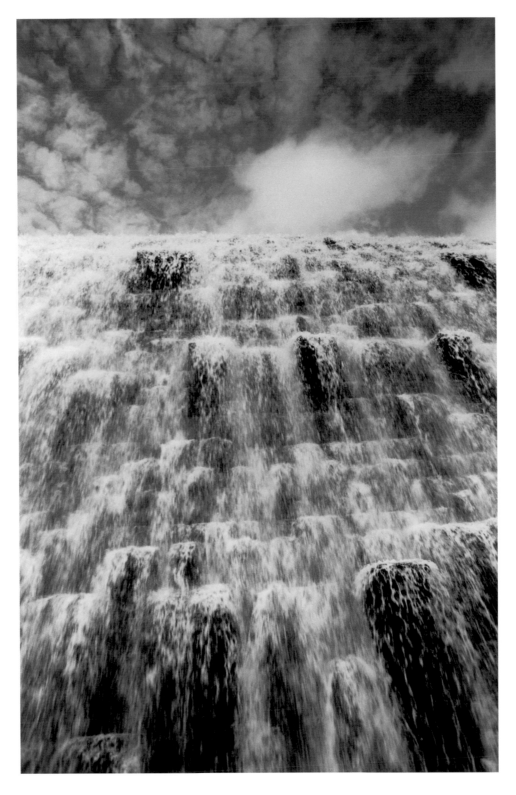

96
Welsh water
David Milano

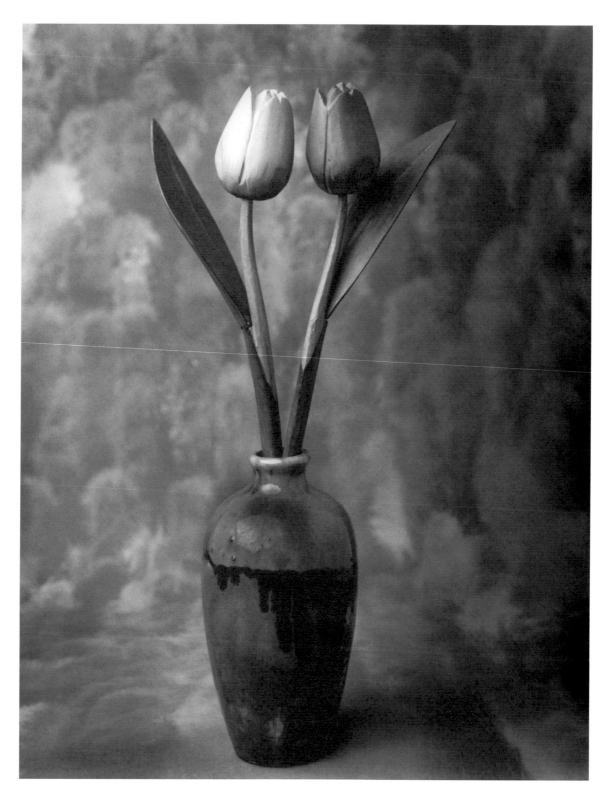

97
Sisters
Daniel Eugenio

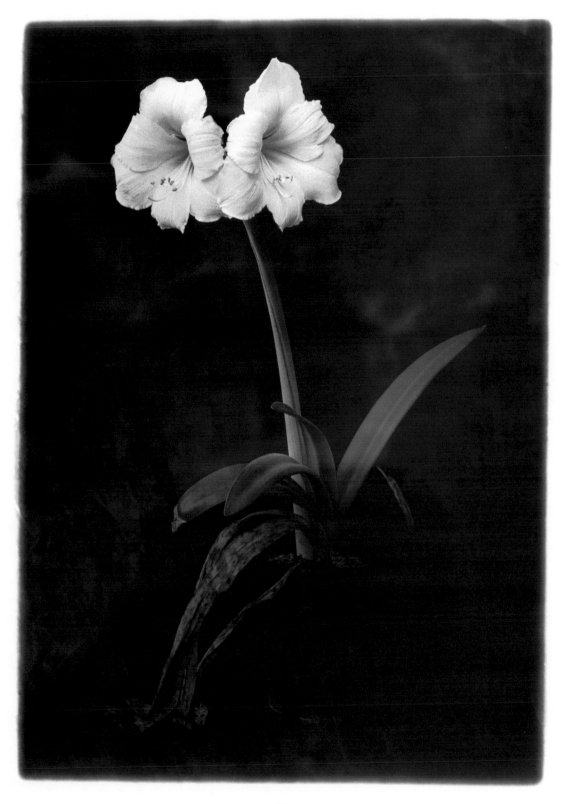

98
Amarylis
Sue Davies

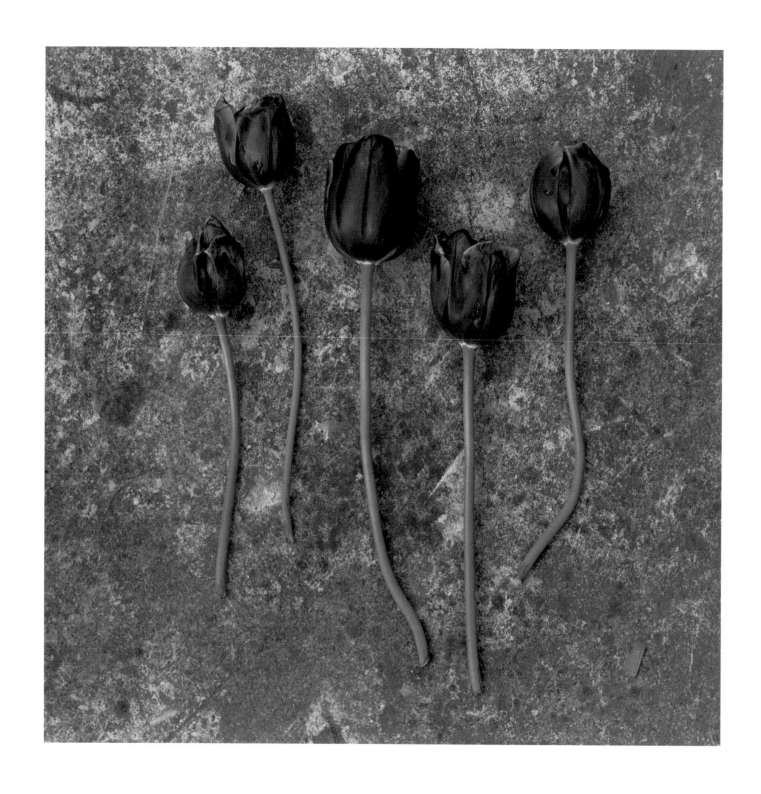

99
Tulips
Andrew Foley

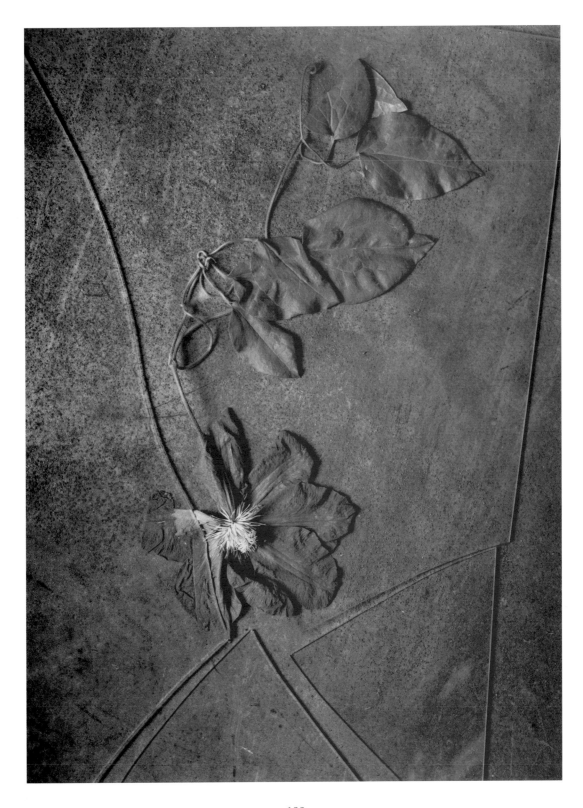

100
Clematis
Ray Spence

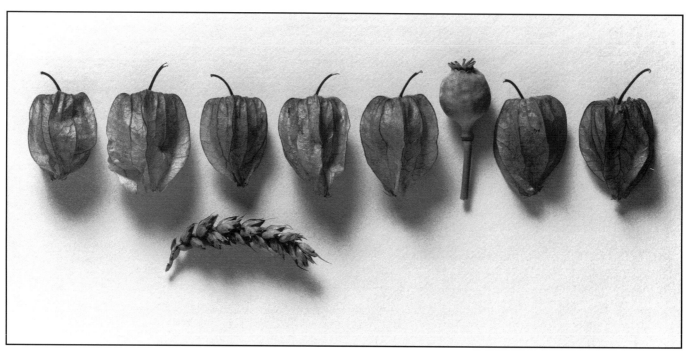

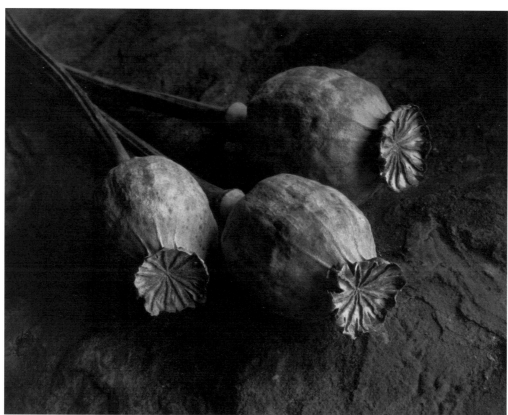

(top) 101 **Still life with seed heads** *Robert Kirchstein*
(bottom) 102 **Poppy heads** *Charles Coldwell*

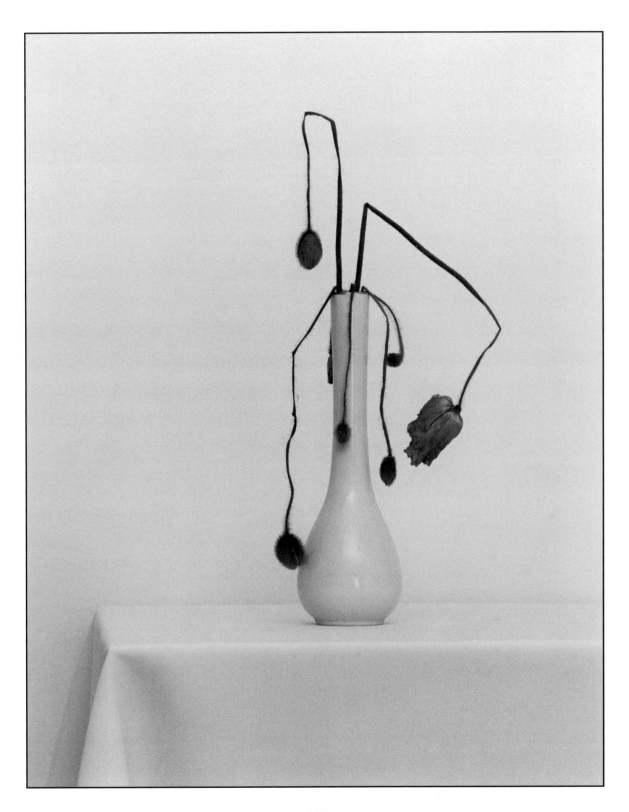

103
Dead poppies, dining room
Fred Hunt

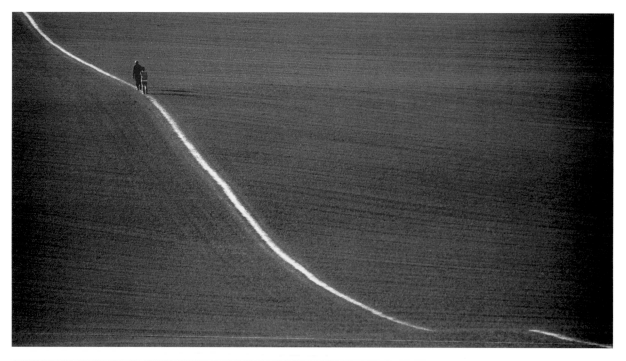

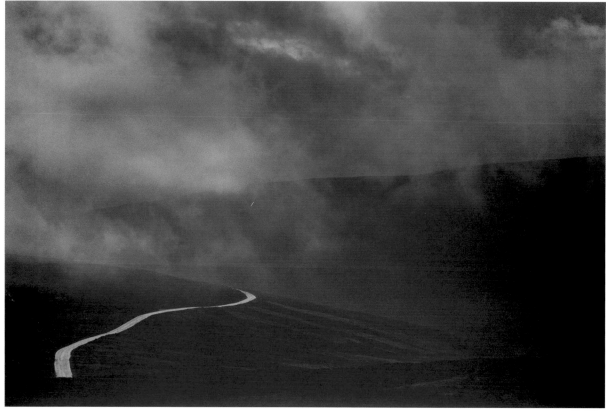

(top) 104 **The path** *Gordon Western*
(bottom) 105 **Cairn o' Mount** *Danny McClure*

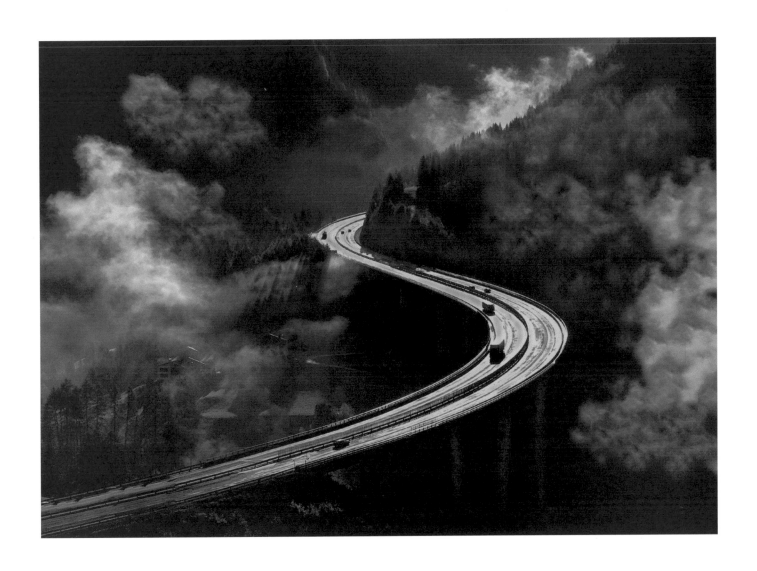

106
Highway
Roy Rainford

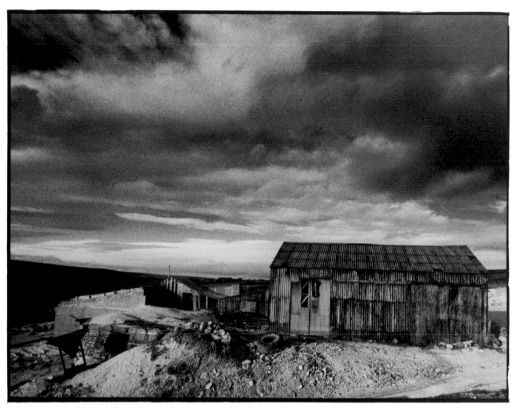

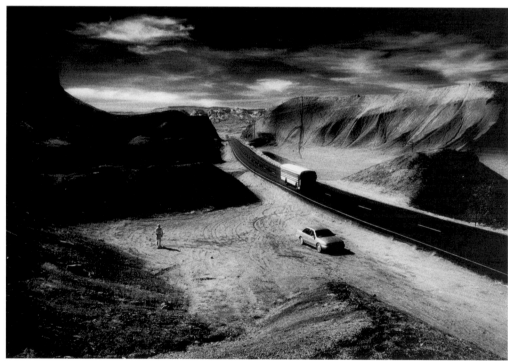

(top) 107 **Quarry detail** *Graeme Hunter*
(bottom) 108 **Highway 24, Utah** *Leigh Preston*

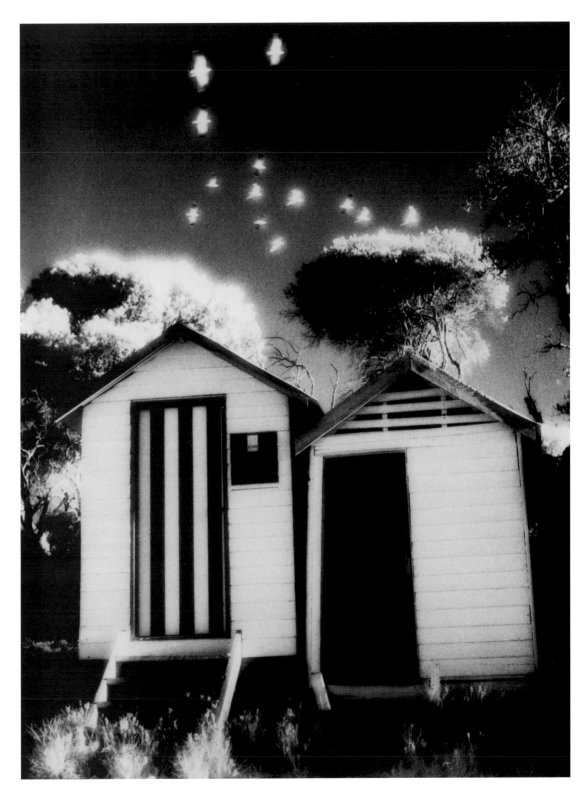

109
Australian summer beach houses
Heather Runting

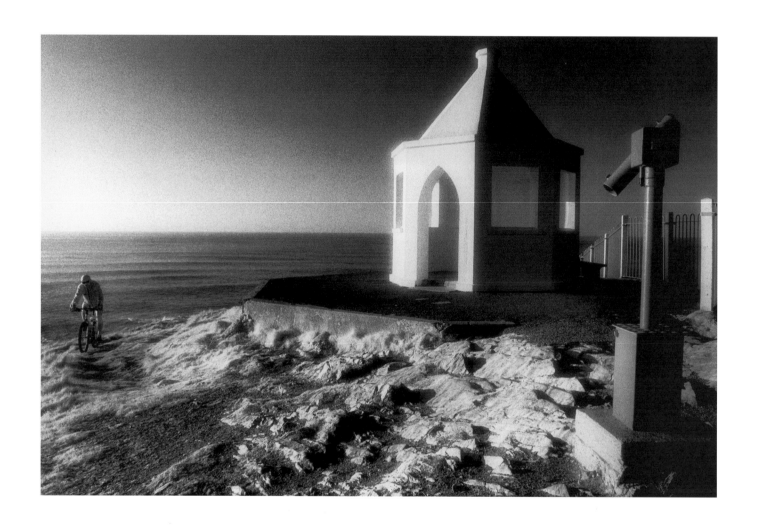

110
Towan Head, Newquay, Cornwall
Alan Lewis

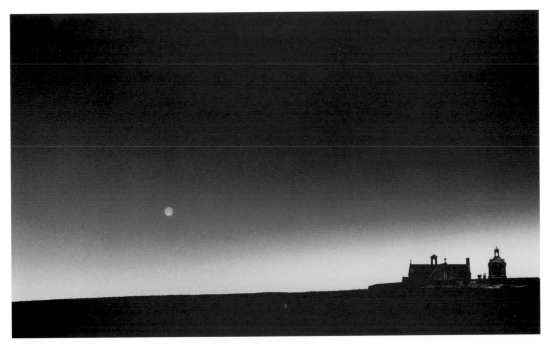

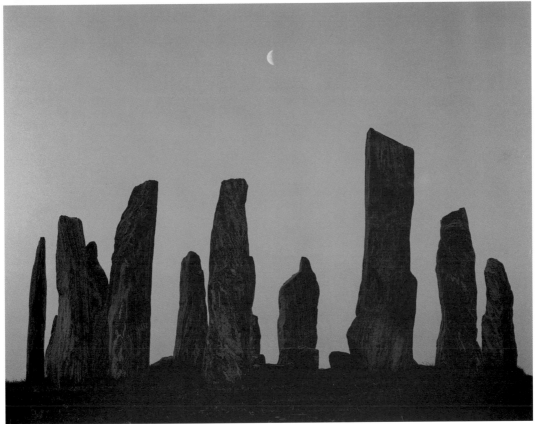

(top) 111 **Moonset #1** *Graeme Hunter*
(bottom) 112 **At dawn, Calanais** *Alfred Hoole*

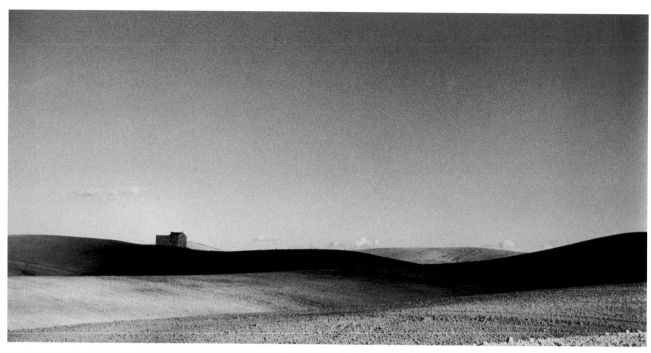

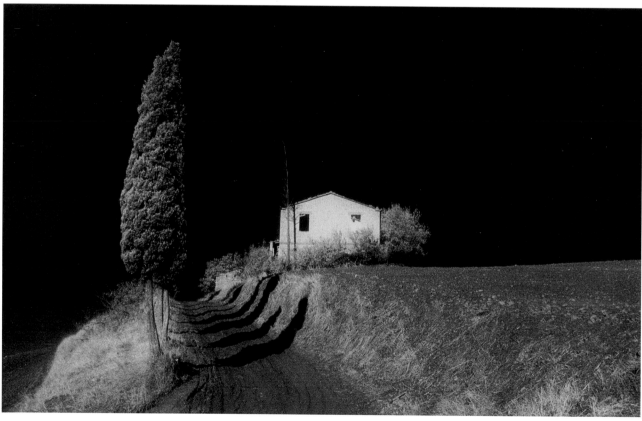

(top) 113 **Under Italian skies #2** *John Nasey*
(bottom) 114 **Under Italian skies #7** *John Nasey*

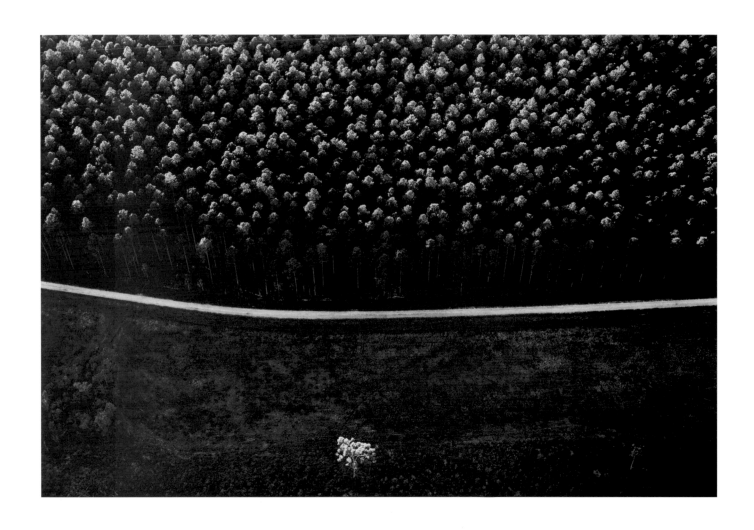

115
Gum tree and pine forest, Queensland
Fred Hunt

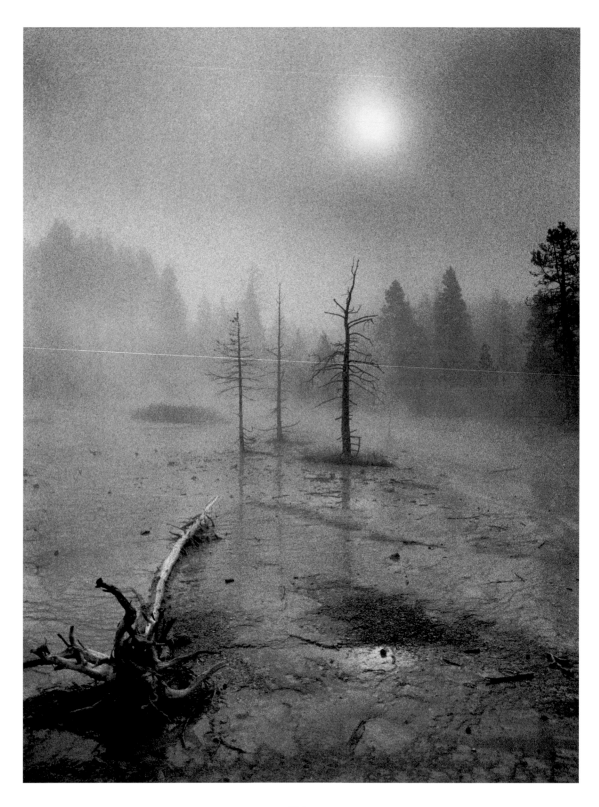

116
Yellowstone
Jim Mansfield

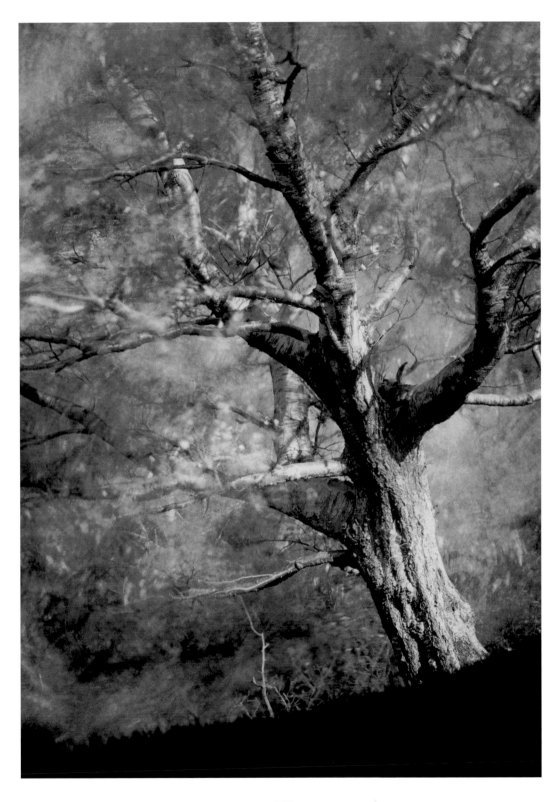

117
Struggle
John Clow

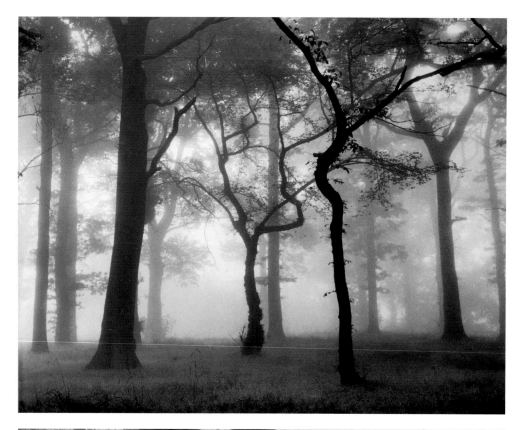

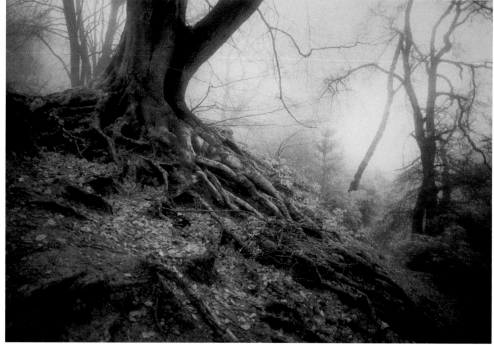

(top) 118 **Trees and mist** *Marshall Calvert*
(bottom) 119 **Roots at Leith Hill** *Alan Thompson*

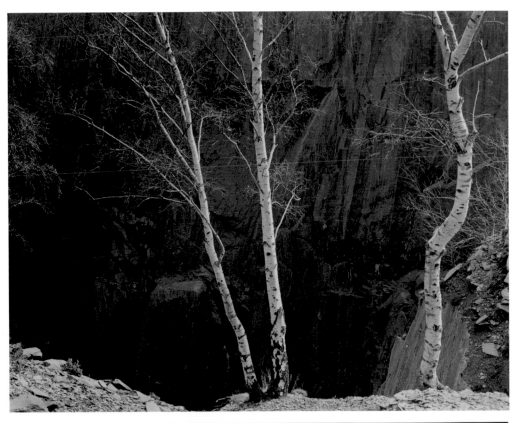

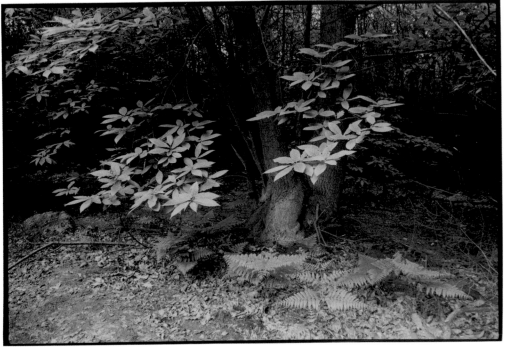

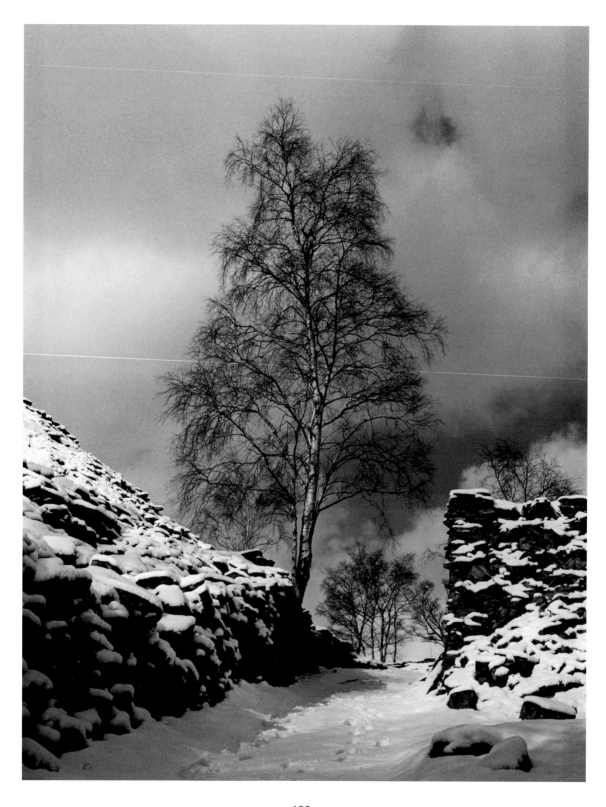

122
Silver birch
Derek Singleton

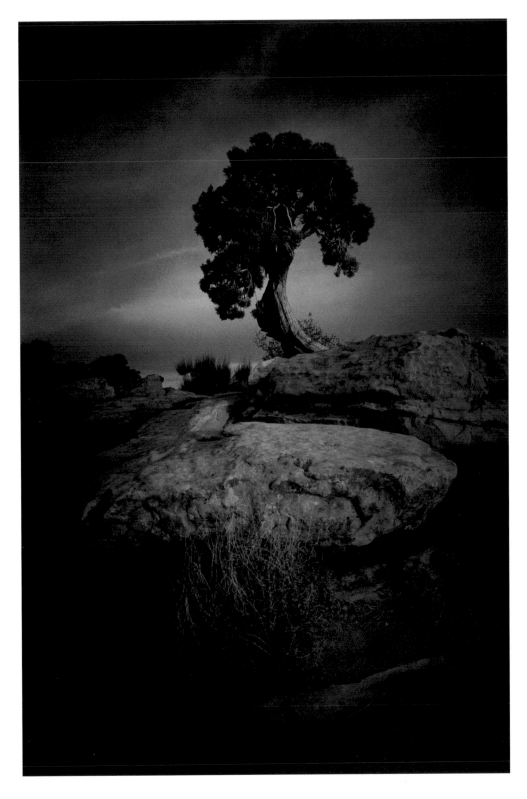

123
Desert dawn
Stuart Lee

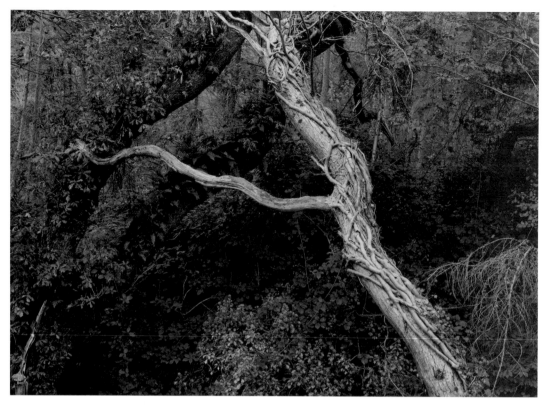

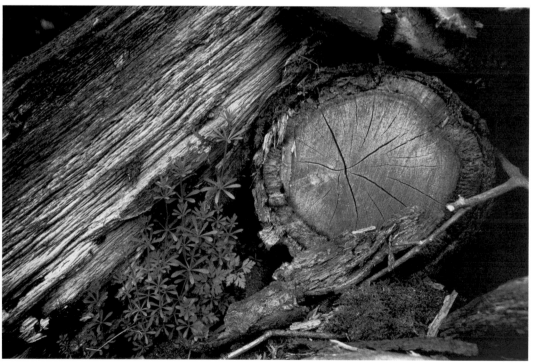

(top) 124 **Millwood, Gower** *Trevor Crone*
(bottom) 125 **The wood pile** *Paul Damen*

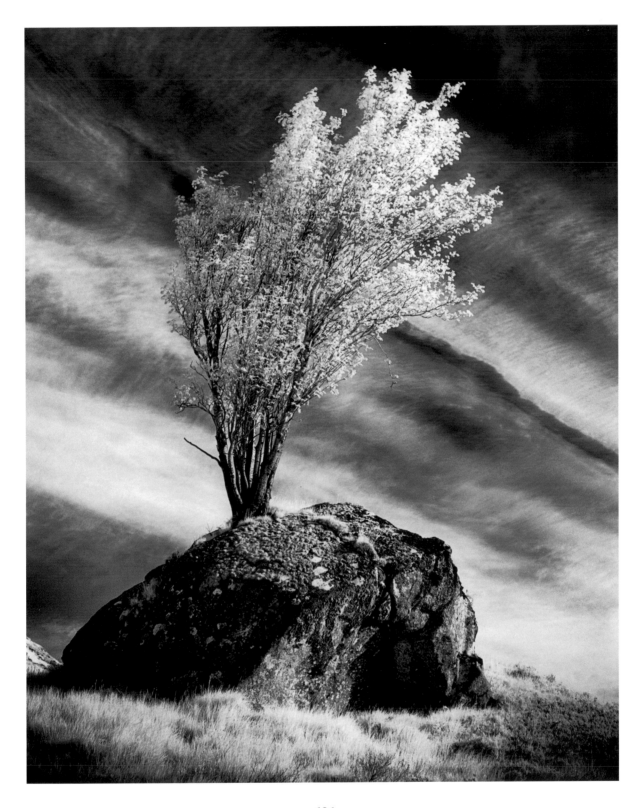

126
Tree and rock
John Riley

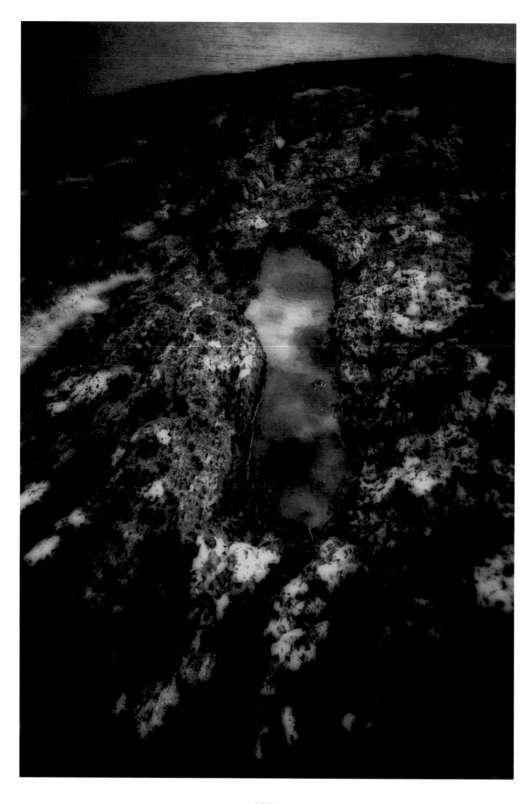

127
Untitled
Neil Bedwell

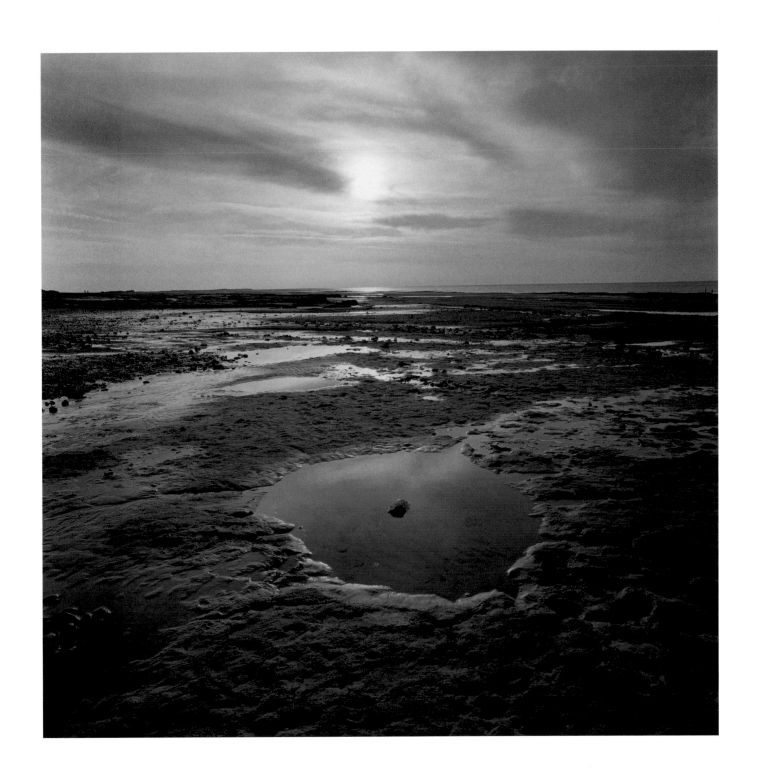

128
Brancaster Bay, Norfolk
John Fenn

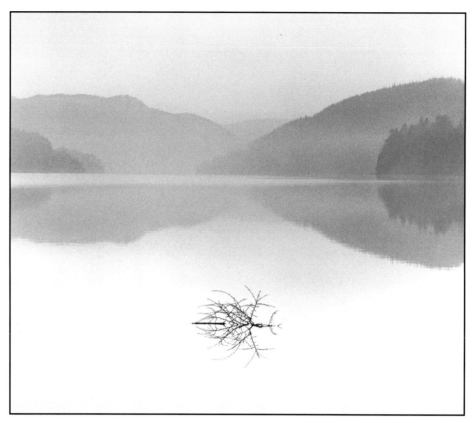

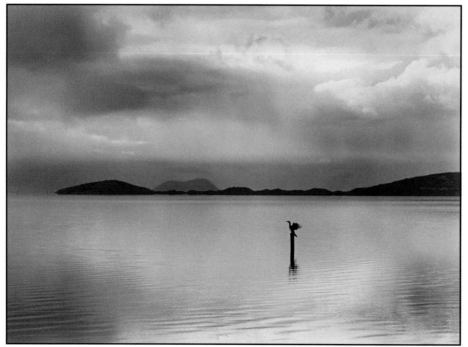

(top) 129 **Thirlmere** *Alfred Hoole*
(bottom) 130 **Silver waters** *Mike Lyons*

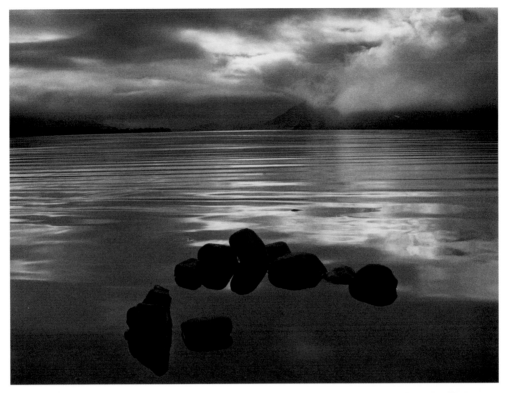

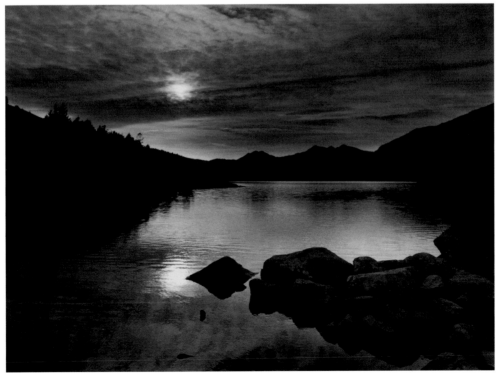

(top) 131 **Bassenthwaite morning** *Chris Upton*
(bottom) 132 **Snowdon** *Richard Pike*

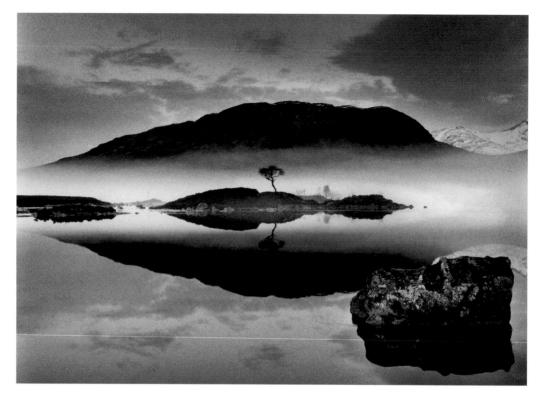

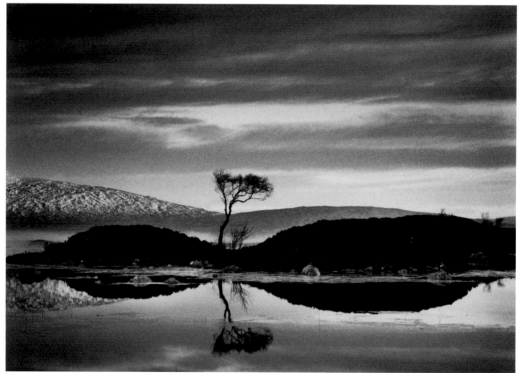

(top) 133 **Black Mount, Rannoch Moor II** *Paul Wheeler*
(bottom) 134 **Black Mount, Rannoch Moor I** *Paul Wheeler*

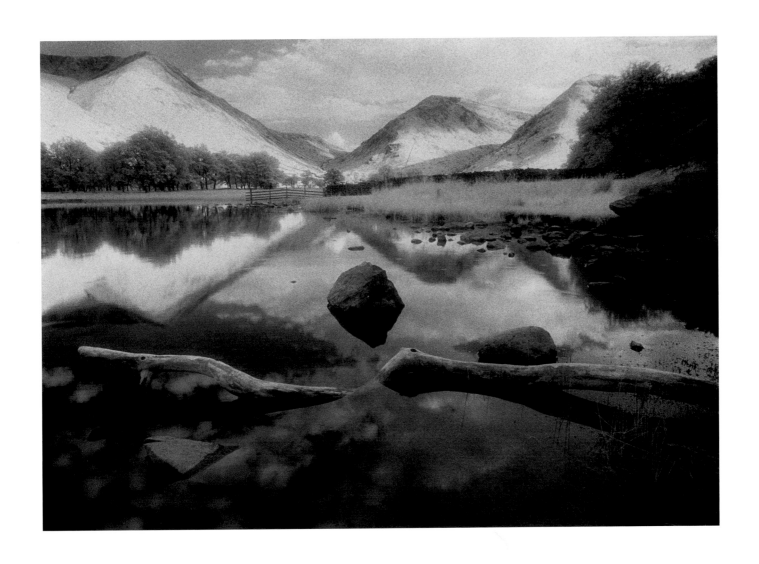

135
Brother's Water
Alastair Rucklidge

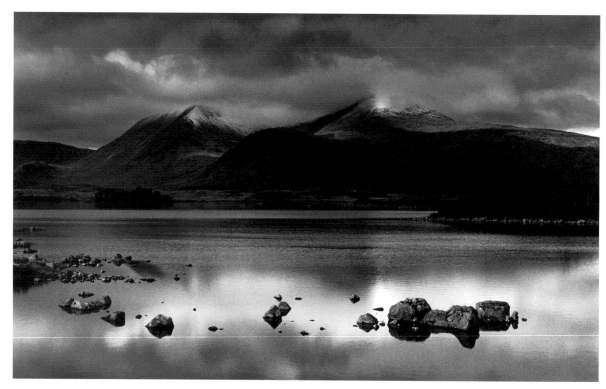

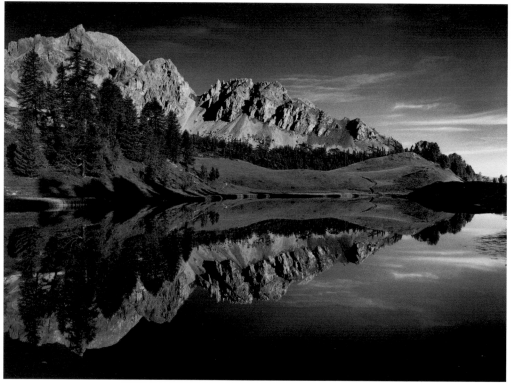

(top) 136 **Lochan** *Brian Ebbage*
(bottom) 137 **Sunrise, Lac Miroir** *Bob Marshall*

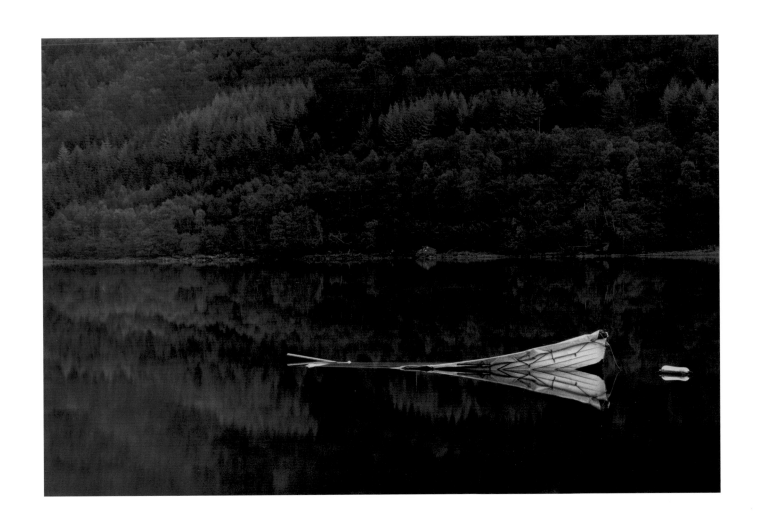

138
Shallow Grave
Paul Booth

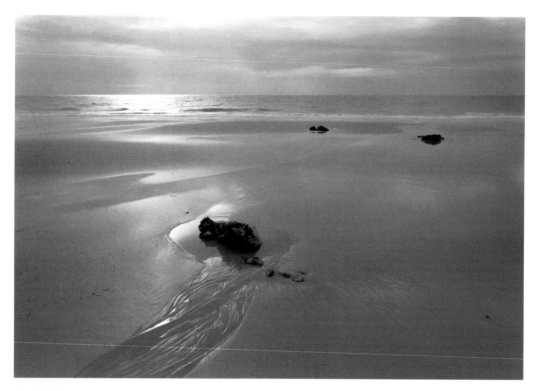

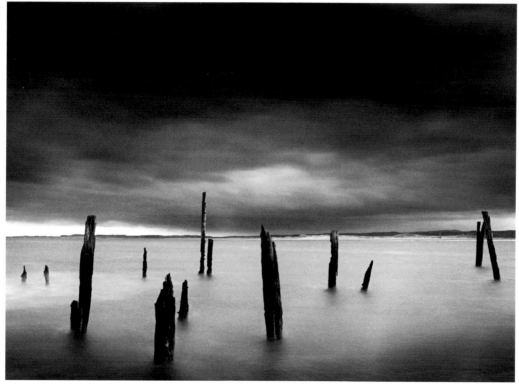

(top) 139 **Tor Bay, Gower** *Trevor Crone*
(bottom) 140 **Seascape, Holy Island** *Alan Thoburn*

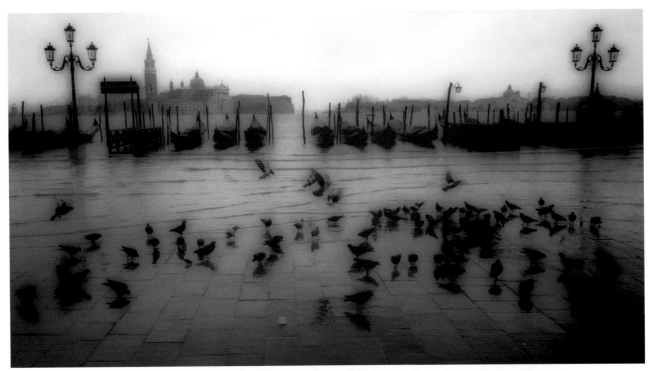

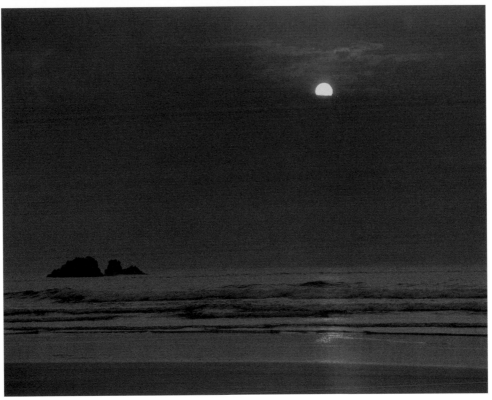

(top) 141 **Venice 1** *Mike Coles*
(bottom) 142 **Sunset, Barrow Beach** *Pat Canavan*

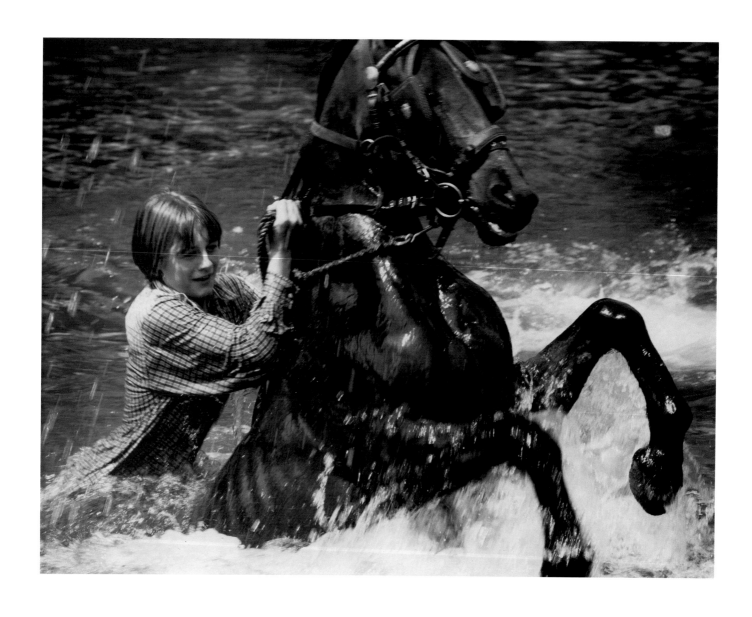

143
Appelby Fair #2
Marshall Calvert

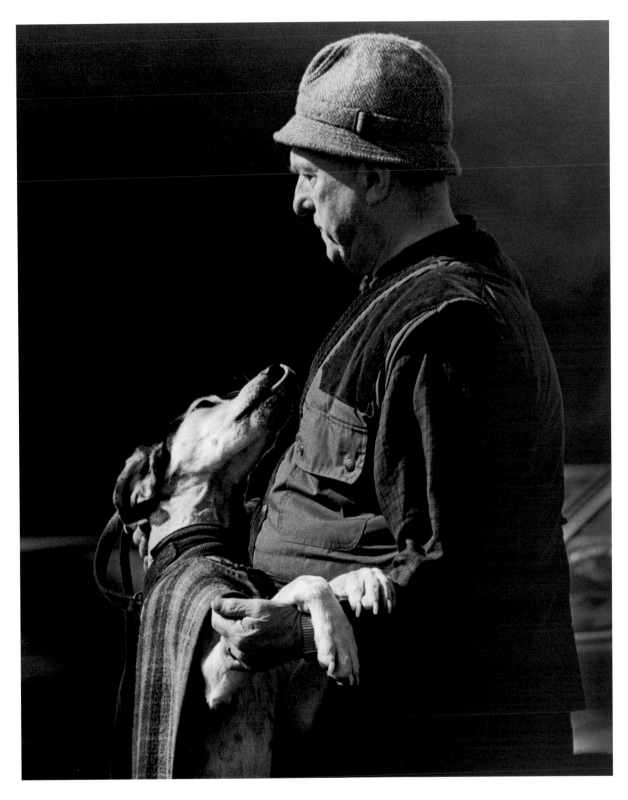

144
Trail hound and master
Hilary Fairclough

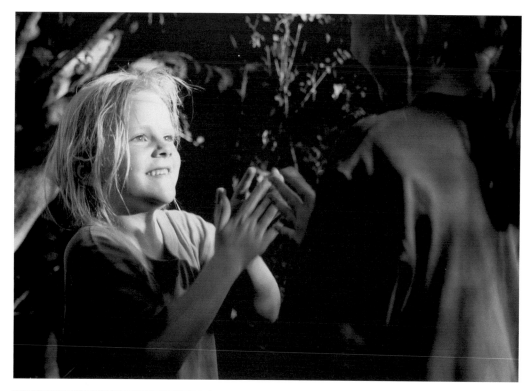

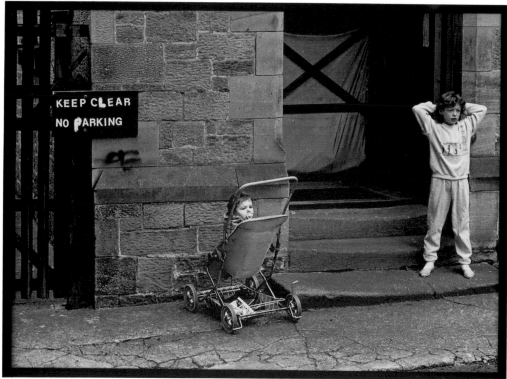

(top) 145 **Pat-a-cake** *Shirlie Phillips*
(bottom) 146 **No parking #1** *Jim Shipp*

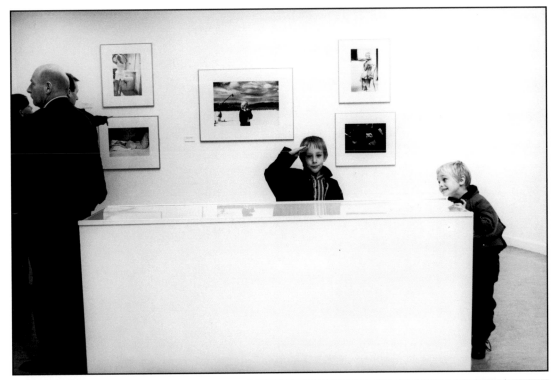

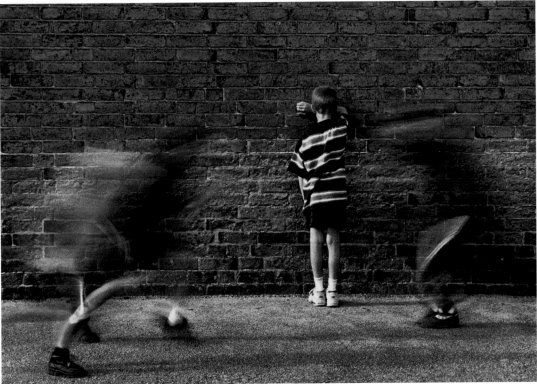

(top) 147 **Salute to Eve** *Michael Mills*
(bottom) 148 **Ready or not!** *Chris Upton*

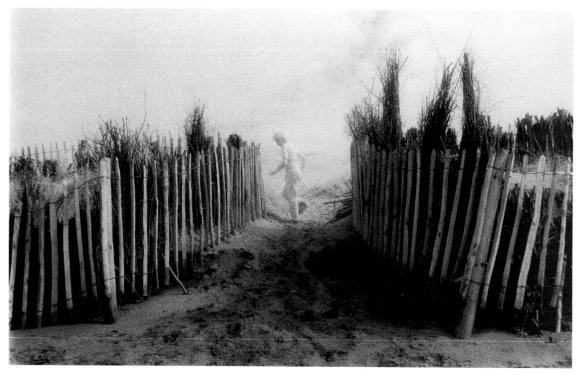

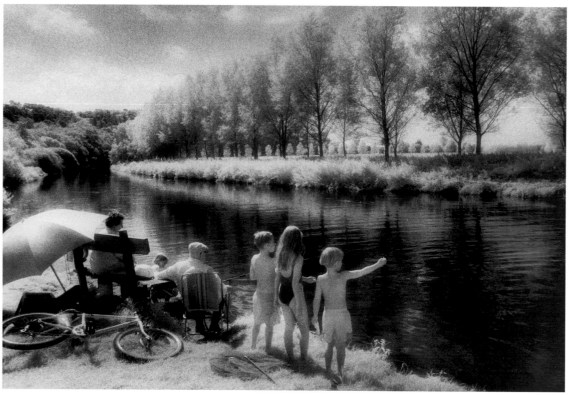

(top) 149 **Vanishing point** *Chris Holt*
(bottom) 150 **Hampshire Avon, near Godshill** *Alan Lewis*

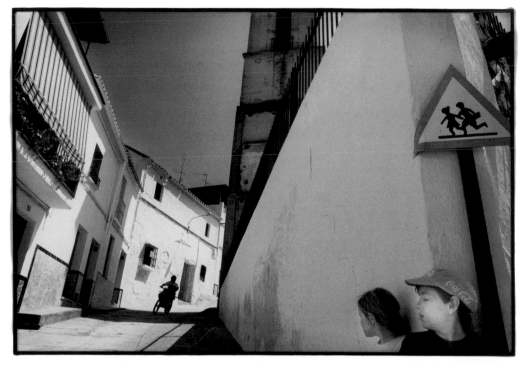

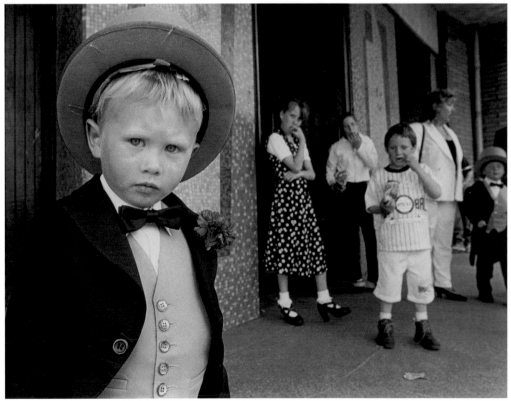

(top) 151 **Hazard** *Steve Boyle*
(bottom) 152 **Dressed** *Des Clinton*

121

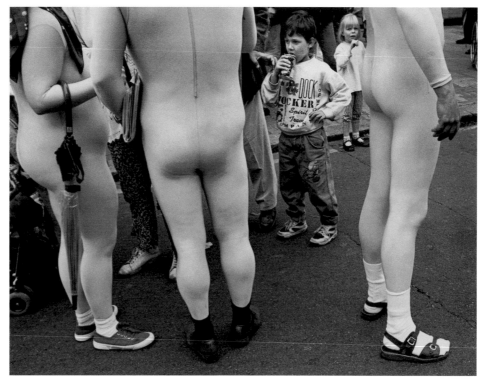

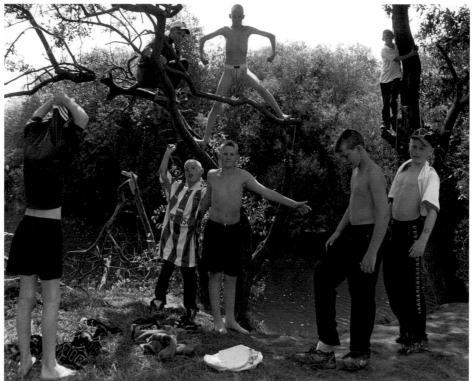

(top) 153 **Bum view** *Clive Harrison*
(bottom) 154 **Boyz** *David Couldwell*

122

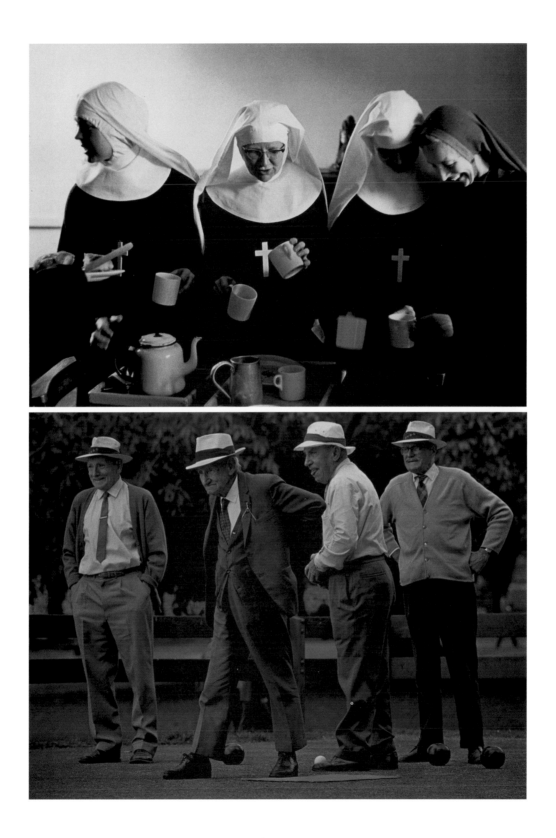

(top) 155 **Nuns' tea break** *Trevor Fry*
(bottom) 156 **Bowlers** *Andrew Smallman*

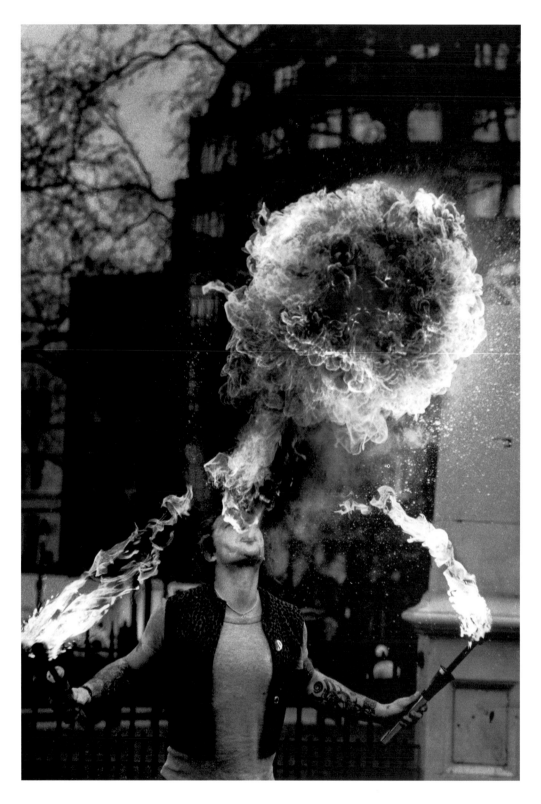

157
Fire eater
Alan Clarke

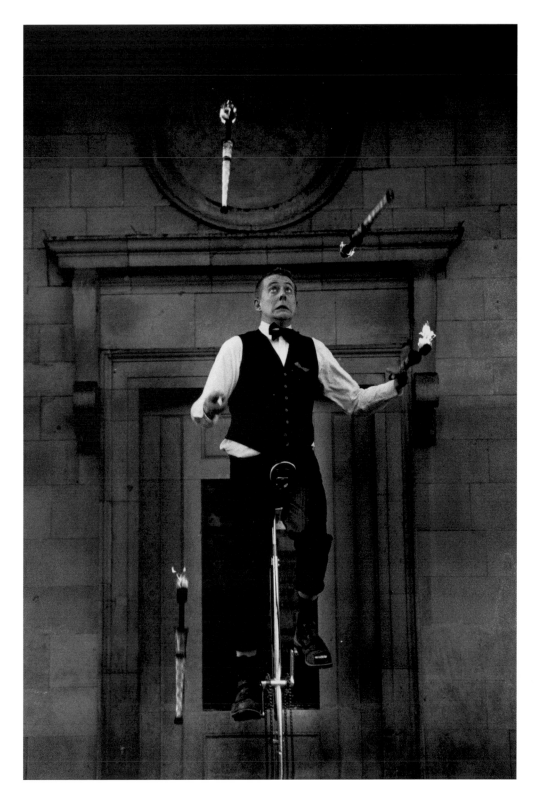

158
An imperfect juggle
Alan Clarke

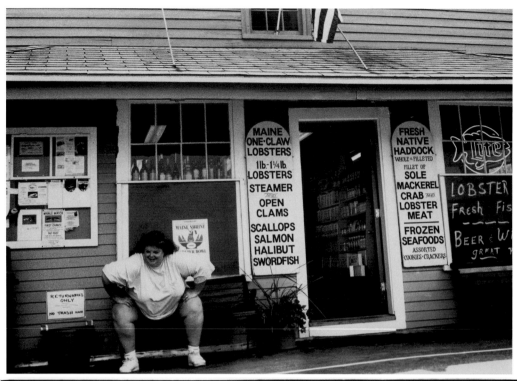

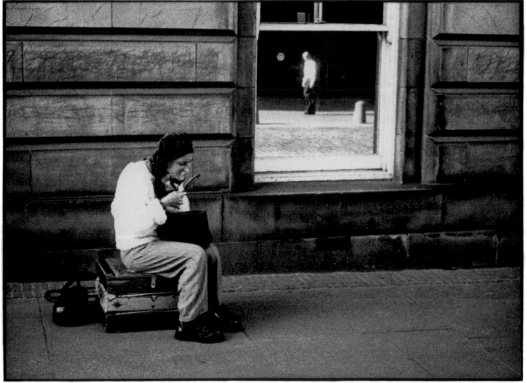

(top) 159 **Lobsters** *Steven Parnes*
(bottom) 160 **Edinburgh candid #1** *Stephen Will*

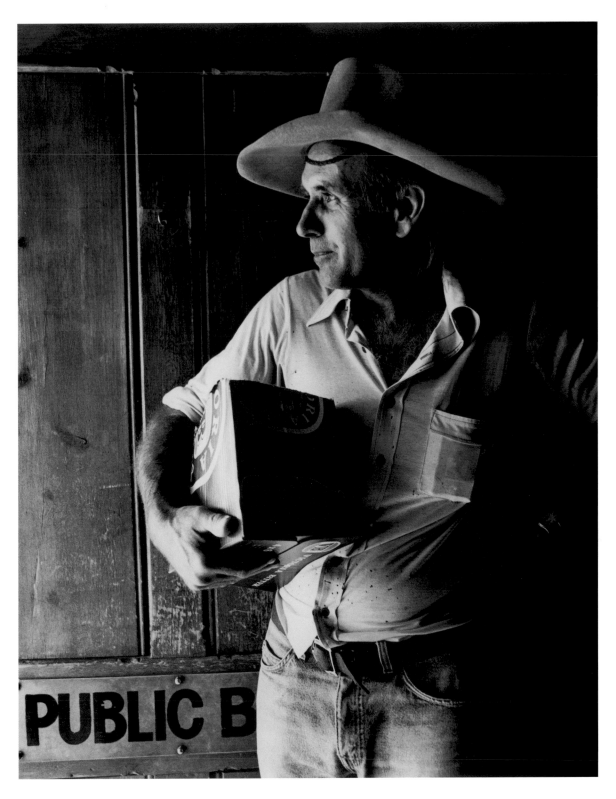

161
Twelve for the road
David Mahony

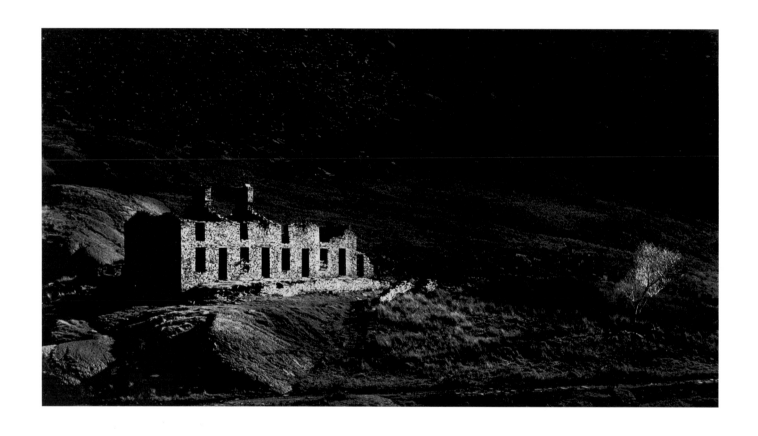

162
The old barracks
Peter Clark

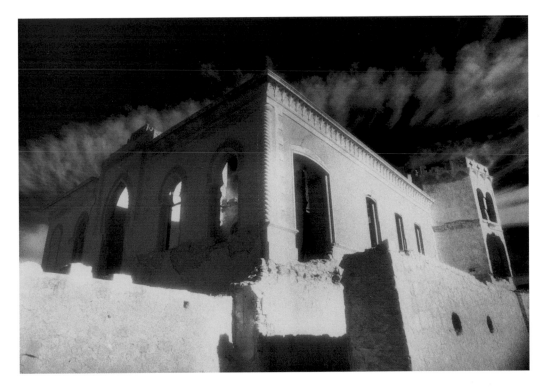

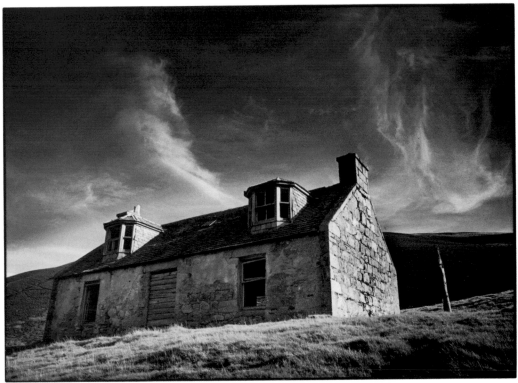

(top) 163 **Abandoned faith** *Alan Brown*
(bottom) 164 **Ruined bothy** *Tom Richardson*

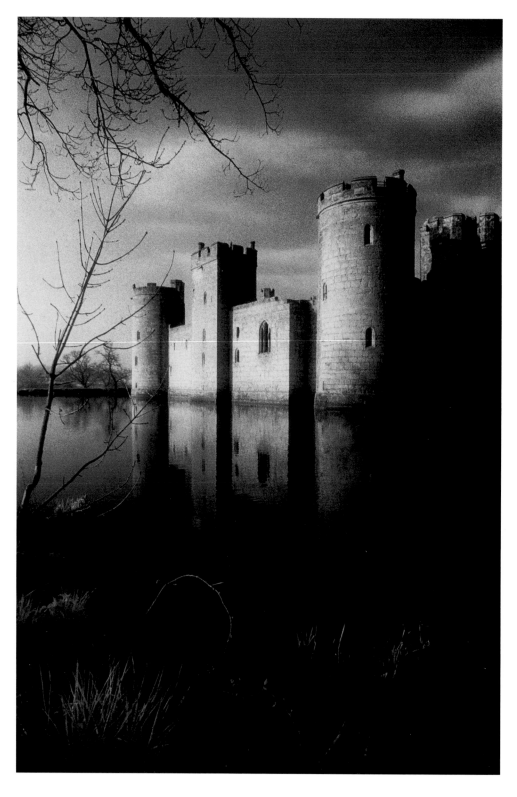

165
Bodiam Castle
David Dixon

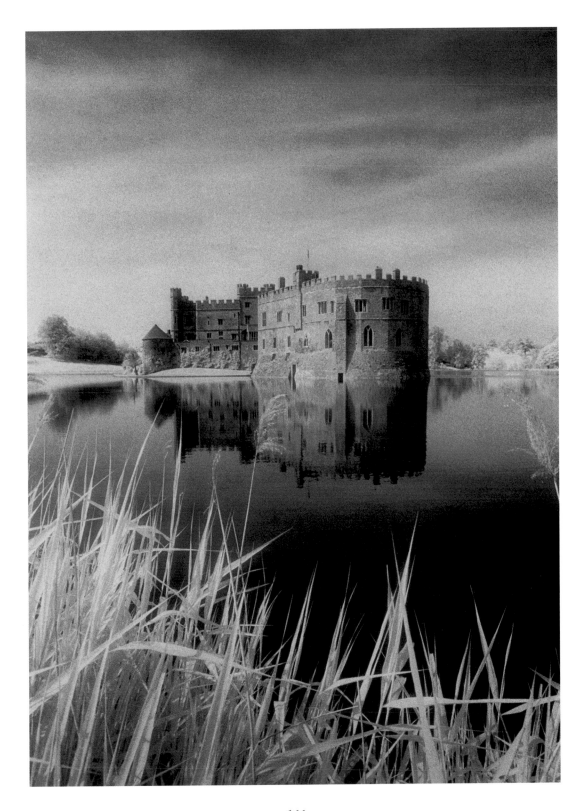

166
Leeds Castle
David Dixon

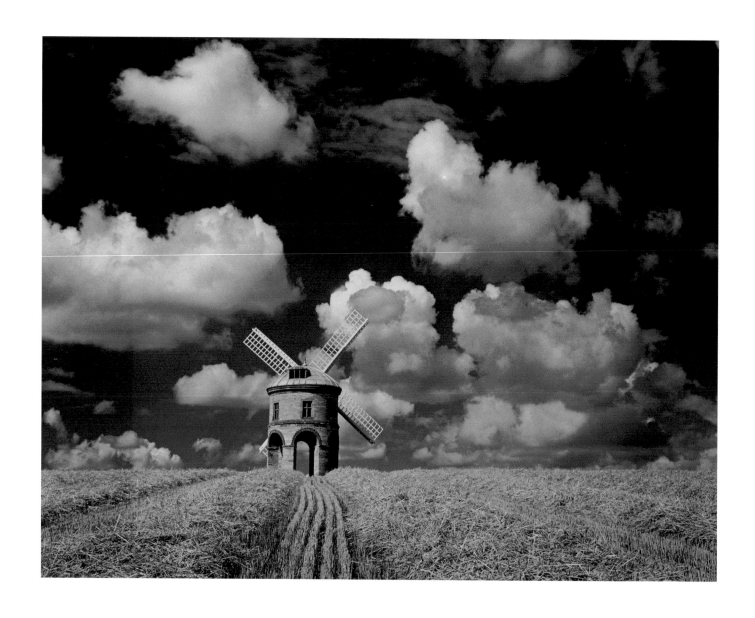

167
Chesterton Mill
Colin Ivison

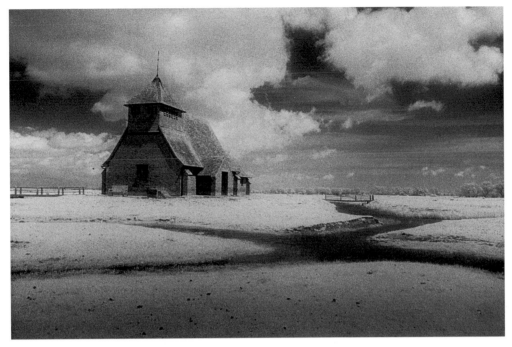

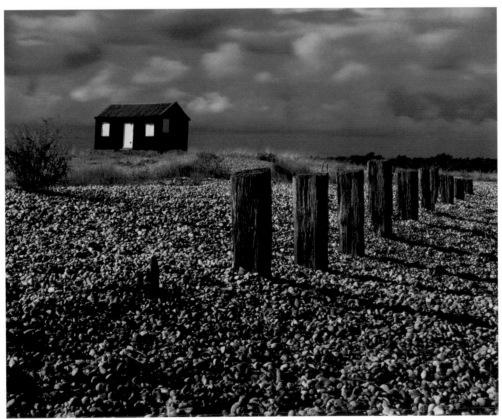

(top) 168 **Church in the marsh** *Peter Moughton*
(bottom) 169 **Harbour hut** *Chris Shore*

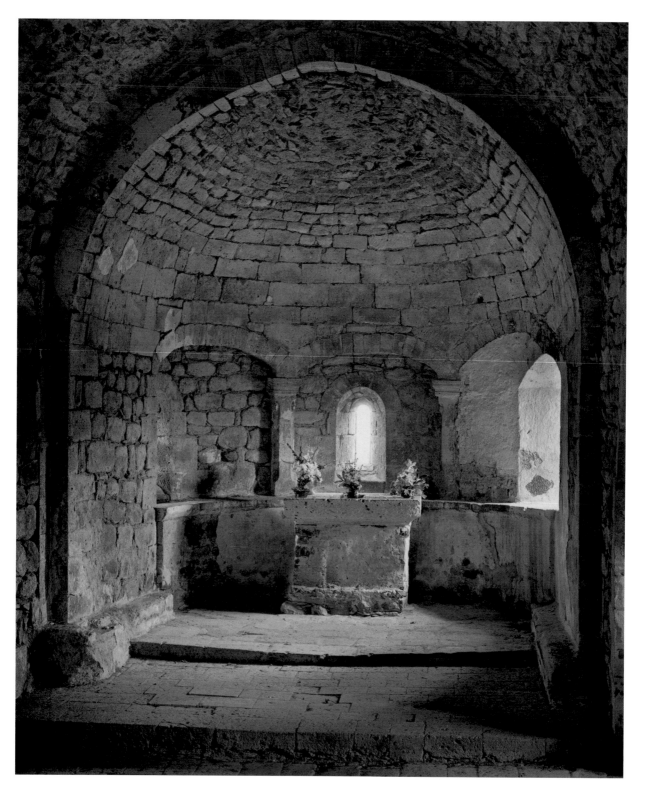

170
Church interior 2
Ron Eaton

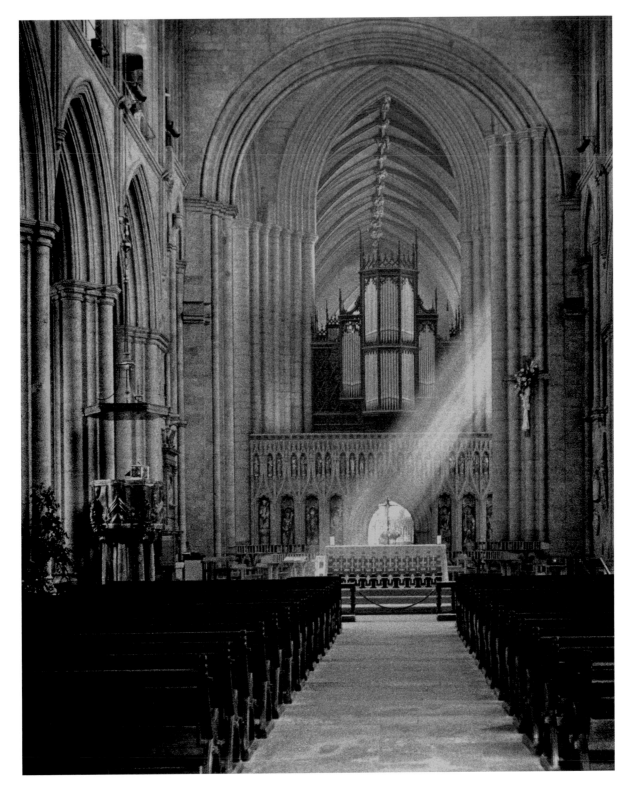

171
Off the record
Colin Snelson

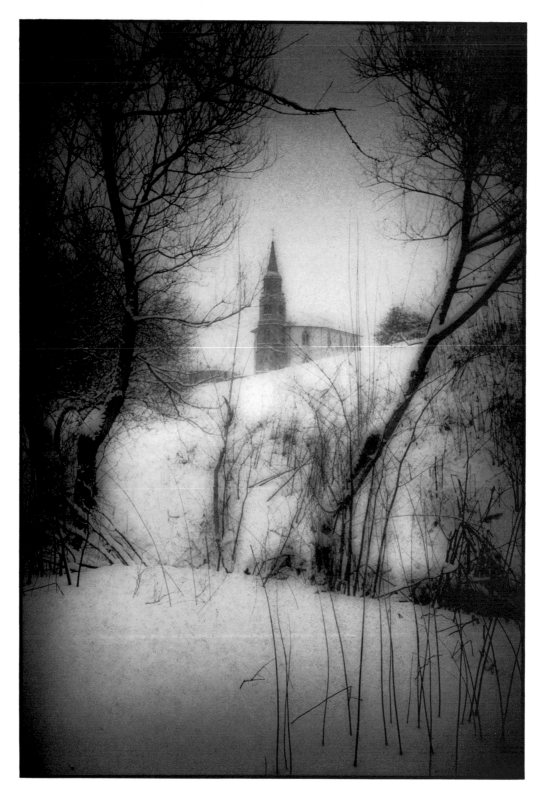

172
Old And Carswell Church, Eaglesham
Joseph George

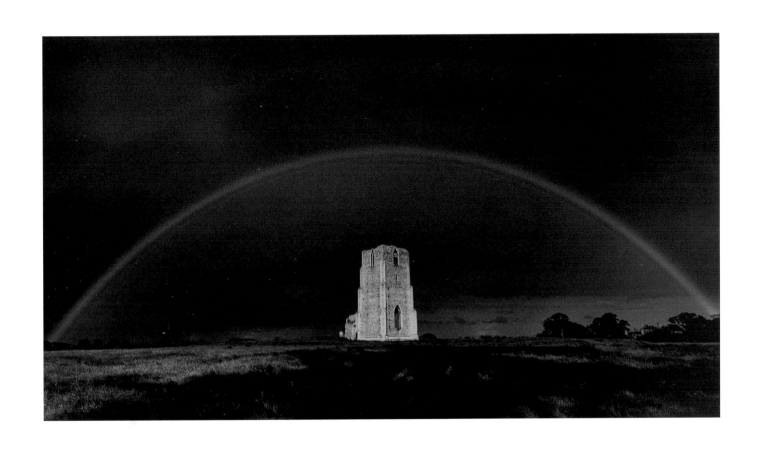

173
Rainbow at Egmere
Brian Ebbage

Contributor profiles

Neil Bedwell *(Lancashire)*
Neil became interested in photography as an aid to painting and drawing. A night school class showed him the creative potential of darkroom work and photography is now his preferred means of image-making. His aim is to convey atmosphere rather than make detailed records of his subjects. *(127)*

Paul Booth *(Isle of Skye)*
Paul has been taking photographs since 1966 when his father gave him his first camera for a school farm trip. He now works as a chef in his own hotel in the Trotternish Peninsula of the Isle of Skye, where he is also able to display and sell his photographs during the open season. *(86, 138)*

Denis Bourg *(London)*
Denis describes his objective as "to enlighten the hearts and minds of the people through showing the extraordinary within the ordinary; the beauty within the mundane". He discovered monochrome infra-red photography in the early 1990s and this has become his favoured and most successful medium. *(61)*

Steve Boyle *(East Sussex)*
At the expense of many other hobbies, Steve became engrossed in monochrome photography after joining Brighton & Hove CC in 1983. Having served as president of the club, he gained his ARPS in 1989 and, with a couple of medals under his belt, he is a sporadic lecturer and exhibitor. *(15, 31, 151)*

Don Breakey *(USA)*
Since retiring in 1989, Don has turned his life-long photography hobby into a full-time career. In addition to teaching photography at a secondary school, Don is involved in commercial photography and leads several annual workshops in the canyon areas of the southwest US. *(80)*

Kevin Bridgwood *(Staffordshire)*
At the age of seven, Kevin took a camera on a school day trip, took snaps of the other kids and then attempted to sell them his results. He didn't make sales, but loved taking the photos, so continued to take snaps for the fun of it – "and still do". *(6, 8, 92)*

Carolyn Bross *(USA)*
Her husband's Valentine's Day gift of a camera in 1985 started Carolyn's romance with photography and the path to a new career. Her monochrome images are often selectively hand-coloured to reflect her emotional response to the subject and these have been widely exhibited and published. *(51)*

Alan Brown *(Staffordshire)*
Although only becoming interested in photography in 1988, Alan has had numerous acceptances in national and international salons and holds distinctions of the PAGB and BPE. He is a member of the highly active Moorland Monochrome Group. *(163)*

Alan Brown *(Tyne & Wear)*
Though known to turn his camera to most subjects, Alan's photographic preference is sport, which he feels is too often dismissed as offering little opportunity for creative work. He has been a member of South Shields PS since taking up photography in 1990. *(22)*

David Butcher *(Derbyshire)*
Having gained The RPS Associateship in 1987, David concentrates on monochrome landscapes, especially mountains. He enjoys darkroom work and is constantly developing his printing skills. He is a member of the Chapel-en-le-Frith CC and gives talks to other clubs. *(11, 13)*

Michael Calder *(Australia)*
A recent convert to monochrome photography, Mike enjoys using infra-red film. An Associate of the APS, he has produced a book of monochrome photographs and has had his work published in several magazines. *(95)*

Marshall Calvert *(Tyne & Wear)*
A photographer for 11 years, Marshall's monochrome interest was influenced by Roy Elwood. He has been a member of Wickham CC for the past 8 years with much success in slide work, with his main interests in abstract and traditional landscapes. Marshall recently won the NCPF monochrome landscape prize for his print, "Trees and mist". *(118, 143)*

Pat Canavan *(Ireland)*
Pat came to photography through his interest in drawing and painting, and has now found photography to be his favoured medium. Access to a darkroom has opened a whole new world of expression in his landscape, still life and portraiture photography. *(20, 142)*

Bill Carden *(Middlesex)*
A member of High Wycombe CC and the London Salon, Bill gained his RPS Fellowship in 1971 and has served on the Pictorial and Licentiateship distinction panels. He is a member of the RPS distinctions advisory board. He is best known for his candid photography of people. *(19)*

Bruno Caruso *(Brazil)*
Bruno has been taking photographs for over 20 years, carrying his Leica with him everyday, usually loaded with black and white film. A member of PhotoGraphus club, he has taken part in several exhibitions in Brazil. *(4)*

Clarence Carvell *(USA)*
Clarence likes to photograph the landscape and things of historical significance. Although Clarence enjoys travel, he prefers to photograph close to home and sets aside one day each week to work in the darkroom. He studied photography in school, but most of his education was gained through attending workshops and visiting many art shows. *(48, 52, 54)*

Christine Chambers *(Surrey)*
This is now Christine's fourth consecutive appearance in *Best of Friends*. She continues to experiment with graphic ideas, as well as enjoying landscape and still life work. She is a member of Selsdon CC and an Associate of the RPS. *(46)*

Mike Chambers *(Surrey)*
Mike has been active in photography for some 15 years, working both in monochrome and colour. Despite involvement in administration at club and federation level, he finds time to enter many national and international salons. He holds the AFIAP, DPAGB and ARPS distinctions. *(7)*

Derek Christy *(Australia)*
Derek joined a camera club in 1988, returning to photography after many years. He now works mainly in monochrome and has had successes in club and national competitions, as well as several exhibitions in Queensland. *(64, 68)*

Peter Clark *(Staffordshire)*
A member of Cannock PS and a Fellow of the RPS, Peter is a well known judge and lecturer. He has achieved over 950 exhibition acceptances, including around 150 awards. He holds the Excellence distinction of FIAP. *(162)*

Alan Clarke *(Surrey)*
Alan has been a monochrome worker for the past 20 years, using 35mm, medium and large format. His main subject interests are urban landscapes and street performers. Alan is a member of Mitcham CC. *(157, 158)*

Des Clinton *(Ireland)*
Des started photography over 30 years ago and enjoys meeting fellow photographers and looking at their work. His favourite subjects are people and the landscape. *(25, 152)*

John Clow *(Northamptonshire)*
John has held nine one-man exhibitions. His work has been exhibited in Russia and last year he held a one-man exhibition in the Belgium town of Genk. He is the author of two books published by CM, *The Mountains of Snowdonia* and *Snowdonia Revisited*. *(117)*

Gerry Coe *(Northern Ireland)*
Gerry is a professional portrait photographer working exclusively in monochrome. His own personal work is prolific and varied. He works to themes, but takes any subject that excites him. He prints all work to archival standards and does his own platinum prints. *(37)*

Charles Coldwell *(South Yorkshire)*
Having been a member of Dronfield CC for 10 years, Charles is now chairman. He enters national exhibitions with work showing his love for photography, especially in sport. He also holds the Associateship of the RPS. *(102)*

Mike Coles *(London)*
Mike has been a keen photographer since the age of nine. A film cameraman by profession, Mike always takes a couple of stills cameras with him on assignments. He works mainly in black and white, and particularly likes photographing people and places. *(141)*

Michael Colley *(Manchester)*
Mike works exclusively in monochrome to interpret the landscapes and cities he has travelled. He seeks to evoke not just the emotional charge generated by the locations themselves, but a sense of 'happening' and of untold stories. *(94)*

David Couldwell *(South Yorkshire)*
When David joined Doncaster CC two years ago, he was amazed by the potential of monochrome and promptly set about making a darkroom in his home. He has now progressed to the intermediate section at the club. If selection to *Best of Friends* is anything to go by, he won't be there for long! *(154)*

Trevor Crone *(London)*
Trevor has had more images published in the *Best of Friends* series than any other photographer. His work has been exhibited and published widely. His personal perspective of Kent is published by Creative Monochrome as *The Intimate Garden*. *(124, 125, 139)*

Paul Damen *(Norfolk)*
Paul, who holds a degree in photographic media studies, is an Associate of the BIPP and the RPS and a member of UPP. He is well known as a judge and as a tutor on photography. He has also produced two videos on landscape photography techniques. *(125)*

Sue Davies *(Buckinghamshire)*
Sue became hooked on photography as a result of enrolling on a City & Guilds modular photography course. Her work, for which she readily acknowledges the influence of John Blakemore, has been widely exhibited. Sue is an Associate of the RPS. *(98)*

Mary Davis *(London)*
Having been involved in photography for several years, Mary has given herself one day a week off from being a full-time mother of triplets and devoted it to photography. She gained the LRPS through the City & Guilds scheme at the University of Hertford-shire. Close-up and still life are her favourite subjects. *(39)*

Lesley-Anne Deaves *(London)*
Lesley-Anne's recent introduction to 'serious' photography has been a creative challenge. She finds that photography is her way of communicating. Her main areas of study are colour travel, garden stock and personal monochrome photography. *(41, 53)*

David Dixon *(Kent)*
A Fellow of the RPS, David enjoys club life at Tonbridge CC and submits work regularly to the international exhibition circuit. Most of his work recently has been with infrared film, which he uses to create a sense of drama and austere mood. David's images won a gold and bronze medal in the 1996 BoF Awards. *(165, 166)*

Tom Dodd *(Gwynedd)*
Tom's photographic interest spans some 25 years and is inseparable from his involvement with the outdoor environment. A well known lecturer, exhibitor and judge, Tom gained his FRPS in 1979. He is a member of the London Salon and the Licentiateship panel of the RPS. *(9, 10)*

Signe Drevsjø *(Norway)*
Signe Drevsjø, who favours monochrome photography, has been a serious photographer for the last 30 years and has taken part in international exhibitions since 1969, gaining many worldwide prizes. Signe gained the EFIAP distinction in 1980. *(24)*

David Dunning *(Hampshire)*
David has been printing pictures for the last three years, since purchasing a second-hand enlarger from a camera club friend. He is a member of Portsmouth CC and finds the regular set subject competitions a motivation to making pictures rather than just thinking about it. *(45)*

Ron Eaton *(Devon)*
Ron has had a serious interest in photography for around 15 years, gaining his ARPS in 1984. For the past 13 years, he has been secretary of the Plymstock Co-Op CC. Preferring monochrome for any subject, he describes himself as "roaming Dartmoor in desperate search for pictures". *(170)*

Brian Ebbage *(Norfolk)*
An enthusiastic club photographer for over 18 years, Brian gained the Fellowship of the RPS in 1991 with a portfolio of monochrome landscapes. Enjoying the unreality and atmosphere of black and white, Brian's subject interests include landscape, nudes and infrared photography. *(136, 173)*

Roy Elwood *(Tyne & Wear)*
Much of Roy's life centres around photography, especially monochrome – an enduring first love. Although eclectic in choice of subject matter, he prefers to work around themes, currently water, nudes, dancers and the Appleby Horse Fair. A Fellow of the RPS, his work has gained acceptances and awards in exhibitions around the world. *(63, 65)*

Martin Emerson *(Kent)*
Martin has been involved in photography for several years, but has only recently adopted a more rigorous approach. His particular interest "stems from the relationship between the art and science of photography, and the mixture of both the technical and aesthetic aspects, which combine to produce the final photographic image". *(121)*

Daniel Eugenio *(West Sussex)*
Daniel started taking photographs at a very early stage in his life due to his father's influence. A member of the Crawley CC and the RPS, David's main subjects are portraiture, landscape, events, people, and animals. *(97)*

Hilary Fairclough *(Lancashire)*
Finding it a more expressive medium, Hilary works mainly in monochrome. She likes the challenge of capturing 'that special moment'. The syllabus secretary of Wigan PS, she holds the Licentiateship of the RPS. *(144)*

John Fenn *(Suffolk)*
John returned to photography about 16 years ago and has learned from participation in workshops at Inversnaid Photography Centre. A solicitor by profession, specialising in criminal work, John is convinced that his empty, people-less landscapes are a reaction to the people he deals with in the 'day-job'. *(128)*

Andrew Foley *(South Yorkshire)*
Andrew has been involved in photography since 1989. He is a member of Mexborough PS and Gamma Photoforum, as well as an Associate of the RPS. His work has been exhibited in national and international salons. *(99)*

Trevor Fry *(Essex)*
Trevor has enjoyed photography since the early 1950s and is currently a member of Cambridge & Saffron Walden club. He is a Fellow of the RPS and frequent exhibitor. Although he also works in colour, he retains a real love for black and white, particularly for his favourite subject, people. *(155)*

Steve Garratt *(Northamptonshire)*
Steve mainly concentrates on landscapes, preferring to work on 'details' rather than open vistas, as he feels this gives more a sense of being 'involved'. Initially his prints were mostly documentary style monochrome; however, he presently gives more of an emotional response with the use of tone, bleach and lith development. *(85, 88)*

Joseph George *(Glasgow)*
Joe's interest in photography stems from his school days and his first job in a processing laboratory. He began taking photography seriously in 1981 when he brought his first slr camera. Printing both in colour and monochrome, Joe finds black and white a more expressive and enjoyable print medium. *(172)*

Kerry Glasier *(Cornwall)*
Kerry started making photographs in the mid-fifties. Since moving to Cornwall, he has been making instinctive landscapes. Self-taught, with much inspiration from Bill Brandt, Ansel Adams and especially Minor White, he finds "focus and clarity are the camera's greatest strengths". *(75)*

Avril Harris *(Middlesex)*
Originally studying at what is now the University of Hertfordshire, Avril's main interest is landscape photography. She enjoys workshops at Inversnaid, where she makes contact with other photographers. A member of LIP, she has had work selected for exhibition in both 1997 and 1998. *(120)*

Clive Harrison *(Berkshire)*
Clive is a member of the London Salon of Photography and a founder member of the Arena group. A regular exhibitor and occasional competition winner, his photos have been printed in many British and European magazines. Clive's book of child photography, *Age of Innocence*, was published by CM. *(36, 153)*

Phil Hartley *(South Yorkshire)*
Inspired initially by a photo-mad relative, Phil's interest in monochrome became dominant. He specialises in toned and hand-tinted images. Since taking early retirement, most of his work has been centred around his small portrait studio. *(66)*

Brian Harvey *(Wiltshire)*
Brian is a retired scientist who enjoys working exclusively in monochrome. He is an Associate of the RPS and a past chairman of the Salisbury CC. Primarily a landscapist, he has work regularly accepted in national exhibitions. *(67)*

Paul Hensey (West Sussex)
Paul has had a keen interest in photography for the past five years. A member of Horsham CC, IPSE and LIP, his main subject interest is photography of people, adopting the 'contemporary' style. (40)

Claire Holliday (Middlesborough)
A student of photography in Teeside, Claire is interested in the social documentary approach, especially the interaction of people in the urban environment. She is currently working on a folio for an exhibition entitled 'Women in camera'. (29, 73)

Chris Holt (Norfolk)
Chris, who is a teacher by profession, has been an avid photographer for 20 years, particularly in monochrome, with a keen interest in infrared. He has been secretary of the Hunstanton CC and his main subject interest is the empty landscape. (149)

Peter Holzapfel (Worcestershire)
Peter has been taking and producing monochrome photographs for the past five years after inheriting his father's camera and darkroom equipment. He feels that photography "encourages a person to see and not just to look – and thereby discover a depth of meaning in even the most common thing". (28)

Alfred Hoole (Lancashire)
Alfred has been interested in photography since he was 12, and in 1955 he joined Accrington CC (of which he is still a member). He is a regular participant in club, federation and national exhibitions. He takes particular pleasure in landscape and architectural work. (112, 129)

Frederick Hunt (Australia)
Fred has been a dedicated monochrome photographer for the past eight years. His major interests have been still life and high key subjects. He was awarded an ARPS in photographic printing last year. (50, 76, 103, 115)

Graeme Hunter (Tyne & Wear)
A photography lecturer at Teeside Tertiary College, Graeme has a particular interest in experimental and 'old' processes, including hand-coated emulsions, transfers and lifts and pinhole images. (107, 111)

Colin Ivison (Warwickshire)
Colin has decided to return to monochrome photography since concentrating on colour for several years, as he feels it is a more creative medium. An "optimistic photographer", Colin attempts to take pictures that are interesting by using subject matter, lighting and atmosphere. (167)

Tom Keely (Berkshire)
Tom has committed more to photography in the past year and simply looks to take images that in their own right have "the power to stop people and provoke thought". (17)

Gill King (Gwynedd)
Gill has been working in monochrome for about 10 years and has a tiny "but perfectly formed" cupboard darkroom. She is a nurse by profession, a horsewoman by inclination, and "when I grow up I'd like to be a photographer!". (60, 74)

Robert Kirchstein (Berkshire)
Robert has been interested in photography for over 20 years and passionate about it for the last five. He is largely self-taught and tackles most subjects, although still life has become something of a speciality. (101)

Stuart Lee (Leicestershire)
Stuart has been mainly working in transparencies for about 30 years, but has come to enjoy monochrome as "the darkroom affords so much more freedom for expression". Stuart concentrates mainly on landscape and natural subjects. (123)

Trevor Legate (Sussex)
An advertising and industrial photographer for over 20 years, Trevor still enjoys the freedom of 'doing his own thing' and disappearing into the darkroom with black and white negatives to be suprised by 'what comes out'. (32)

Alan Lewis (Bristol)
Alan, after early retirement from engineering, spent nine years as a freelance specialising in industrial photography. A member of Thornbury CC since 1970, he joined the RPS in 1984. Alan has gained his Licentiateship and is aiming towards an Associateship with an infrared submission. (110, 150)

Mike Lyons (Australia)
A dentist and self taught amateur photographer, Mike prefers land and seascape monochrome photography. Awarded the LAPS in 1996 and a member of Western Australian Photographic Judges Asscociation, Mike has recently moved up to medium format work. (130)

David Mahony (Australia)
David is the only photographer even to win a gold, silver and bronze medal in a single Best of Friends Awards. His work has been exhibited and published around the world. He holds the Artist distinction of FIAP. (161)

Roger Maile (Surrey)
Roger is the director of Creative Monochrome and consequently has depressingly little time to pursue his own photographic interests – mainly people photography and a growing fascination with digital imaging. (82)

Jim Mansfield (Hampshire)
Jim has been an avid monochrome worker since joining the Southampton CC in 1953. He has been involved in helping to make a comprehensive archive and AV of work by local photographers, dating back to 1906. (116)

Bob Marshall (Buckinghamshire)
Bob is a member of Amersham PS and has been hooked on photography since taking his first picture on a Brownie box camera 39 years ago. He works only in monochrome and increasingly with landscapes and nature abstracts. (9, 93, 137)

Danny McClure (Midlothian)
Preferring to produce good monochrome work, Danny, who is also a colour slide user, is a member of Edinburgh PS, the RPS and Club Rollei. His first love is landscape photography but, for a complete change of scene, he also makes sport images, particularly cycling. (105)

Tyrone McDonald (Hampshire)
Having rediscovered monochrome a couple of years ago, Tyrone comments: "I find I am on a new learning curve – a learning curve of looking and looking again – a new or resurrected perspective. Frustration seems to come more rapidly in senior years, obstacles appear to be greater. However, obstacles and hurdles are there to be overcome." (16)

David Milano (West Midlands)
With just four years' experience of photography, this is Dave's first piece of published work. Although black and white landscape is a particular favourite, his interests cover the whole spectrum of photographic subjects. (96)

Michael Mills (Derbyshire)
With no previous interest in photography, Michael attended a City & Guilds photography course, which he completed in 1995. Living on the outskirts of the Peak District, he enjoys walking and photographing the landscape; however, his main photographic interest is people photography. (147)

Reuven Milon (Israel)
Reuven's photographic work started in 1949, initially as a hobby and then as a profession. He has worked for the Israel Museum for many years. His personal preference is for monochrome work. (62)

Martin Mordecai (Canada)
Martin has been making photographs since 1973. His main subject interests are landscape and figure photography. In 1997 he held his first solo exhibition in Jamaica and regularly enters the annual Jamaican Awards. (34)

Peter Motton (Australia)
Peter became interested in large format photography while working in the graphic arts industry from 1960 to 1975. Since moving to Tasmania in 1975, when he bought his first 35mm camera, he has spent some years as a technician in print media at the University of Tasmania. (18, 77)

Peter Moughton (East Sussex)
A photographer for more years than he cares to remember, he is currently a member of the Hastings and St Leonards CC. He has tackled most subjects, but has generally found most satisfaction in natural history and landscape photography. He holds the Licentiateship distinction of the RPS. (168)

John Nasey (Jersey)
John was the gold medal winner in the first Best of Friends Awards. He is a Fellow of the RPS and has been entering national and international salons with considerable success since 1988. (113, 114)

O Tudur Owen (Gwynedd)
Since retirement five years ago, Tudur's darkroom work has improved considerably. He is a member of two postal portfolios and of Club Camera Blaenau Ffestiniog. Most of his photographs are taken in the Welsh mountains. (5, 12)

Steven Parnes (London)
Steven is a chartered surveyor who took up photography about 7 years ago when pressures of work reduced. He now is an Associate of the RPS and, time and money allowing, travels the world to practice his hobby. He has held one exhibition and is in the process of planning a second. (159)

Gary Phillips (West Midlands)
Interested in photography since 1983, Gary built a darkroom at the bottom of his garden in 1990 and joined the Cannock PS. He now judges and gives talks to local camera clubs. (30, 70, 87)

Shirlie Phillips (Australia)
A keen photographer for the past five years, Shirlie enjoys all subjects, with a preference for photographing women and expanding her images to mixed media. She has been successful in national and international competitions. (145)

Richard Pike (Berkshire)
Richard has been interested in taking pictures since his school days. He is a member of the Newbury CC, where he has been competition and programme secretary. His main interest is in making monochrome landscapes and he is hoping to try for his ARPS next year. (3, 132)

Brian Poe (Ross-shire)
An artist and teacher, Brian describes his purchase of a medium format camera as self-indulgent, but had the commitment to build a darkroom and teach himself some photographic craft. He describes his influences as abstract expressionism and surrealism, which he believes to be indicative of his vintage! (1)

Leigh Preston (Gloucestershire)
Leigh is a well known lecturer and judge on the club circuit and is a member of the RPS Licentiateship distinctions panel. A regular exhibitor in national and international salons, Leigh is the author of Shadows of Change, published by CM. (26, 27, 108)

Stewart Prince (Northumberland)
A member of Cramlington PS, Stewart has been interested in photography for over 20 years and monochrome for over 10 years. Particularly interested in mountains, he has an extensive colour slide record of Britain's mountain regions, which he finds irresistible. (90, 91)

Roy Rainford (Surrey)
An Associate of the RPS, Roy has been a member of Woking PS for the past 15 years. He participates in competitions and exhibitions and has had his work published widely in Europe. His main areas of interest are landscapes, nature and travel. (106)

Rolf Raucheis (Germany)
Returning to photography after some years, Rolf joined a club in 1992 and now mainly works in monochrome. His interests in photography are landscape, people, detail and structure. He has had successes in national and international competitions. (71)

Den Reader (Norfolk)
Den has held a number of solo exhibitions and his work has been included in numerous publications and is represented by a major picture library. This is the third consecutive occasion that his distinctive still life images have graced the pages of Best of Friends. (47, 55, 57)

Tom Richardson *(Lancashire)*
Tom has taken a serious interest in photography over the past 11 years, with the landscape as his preferred subject. His work has been accepted for numerous national exhibitions. He is an Associate of the RPS and a holder of the BPE distinction. *(164)*

John Riley *(Liverpool)*
An Associate of the RPS, John's enthusiasm for monochrome photography goes back over 30 years. Finding monochrome a more exciting medium, many of his prints show strong, simple composition. Two years ago he and three friends formed the North West Monochrome Group, whose aim is to encourage monochrome photography – it is proving very successful. *(126)*

Cleif Roberts *(Gwynedd)*
Taking up photography around 8 years ago, Cleif is a member of Club Camera Dendraeth and works solely in monochrome. His main interest is portrait photography. *(35, 89)*

Alastair Rucklidge *(Cambridgeshire)*
Alastair's interest in photography began three years ago when he joined Cambridge CC. He has worked in infrared for the past two years and mainly works in monochrome. Alastair has also recently begun to experiment in the digital medium. *(135)*

Heather Runting *(Australia)*
Mainly a self taught photographer, Heather joined the Knox PS in 1990 and began to learn more through interaction with other photographers. She has been a photographer since the age of eight, when she inherited her mother's old Box Brownie and now mainly photographs weddings and children. *(109)*

Andrew Sanderson *(West Yorkshire)*
After a three year course at Dewsbury and Batley Art College, Andrew worked as a press photographer and black and white printer until going freelance in 1987. Posters of his work have been sold throughout the world and his work has been acquired almost as extensively for private collections. *(14, 42, 44)*

John Seely *(Herefordshire)*
John is a writer and editor of educational books. He has used his own colour slides, usually of documentary/human interest subjects, to illustrate many of his books. He spends part of each year in France, where he concentrates more on black and white pictorial work. *(49)*

Jim Shipp *(Northumberland)*
After a number of years producing nature slides, Jim now prefers to work in monochrome, but still enjoys and appreciates all forms of photography. *(146)*

Chris Shore *(Kent)*
For Chris, the joy of photography is to be in an isolated spot in good weather, finding an old derelict building and trying to turn it into a well composed image. He finds that his favourite haunts in the Romney Marsh offer these elements in abundance. *(169)*

Derek Singleton *(Cumbria)*
Derek took up black and white photography in the mid-1950s and, like many at that time, was seduced by colour slides. He returned to monochrome in the early 1980s and has developed a strong feeling for the West Highlands of Scotland, seeking to capture on film the atmosphere of this wild and remote part of the country. *(122)*

Roger Slade *(Essex)*
Roger has been interested in photography for many years, initially through borrowing his father's camera as a child. He is keen to keep developing a 'seeing eye', find new ways of looking at the world, largely through producing monochrome images of people and landscapes. *(43)*

Andrew Smallman *(Australia)*
Andrew has been intrigued by photographs and the process of making them since his father bought a Baldafix camera when he was ten years old. Andrew uses colour and black and white, although the latter is gaining prominence as time goes by. *(156)*

Colin Snelson *(North Yorkshire)*
Being asked, as a science lecturer, to teach basic photography to an evening class, Colin's interest deepened as some of his students began gaining RPS distinctions. Since then, sharing and competing with other photographers, building and developing a darkroom and getting his own modest distinction have continued the process. *(38, 171)*

Neil Souch *(Devon)*
Neil's photography mainly features the varied landscape of the west country and he counts himself fortunate to live in such an inspirational area. He is a keen exponent of mono infrared photography and is also the secretary of two RPS postal folios. *(79, 83)*

Hugh Spence *(Bedfordshire)*
Hugh has been interested in photography for a long time, but his serious involvement began in 1993. He was a member of Aperture before relocation from London and is now a member of St. Neots CC. *(69)*

Ray Spence *(Warwickshire)*
Ray's passion for photography was kindled while taking a degree in microbiology. After a 12 year stint as a biology teacher, he chose to lecture in photography and media studies. He is a Fellow of the RPS and has lectured and exhibited widely in the UK. In 1994, Creative Monochrome published a portfolio of his work, *Form and Fantasy*. *(100)*

Steve Terry *(Isle of Skye)*
Steve and his wife recently opened a photographic holiday centre on the Isle of Skye, where he hopes to find more time for monochrome landscape work. He is an Associate of the Royal Photographic Society. *(84)*

Alan Thoburn *(Tyne & Wear)*
Alan has been practicing photography for about eight years and is currently a member of Gateshead CC. Interested in all aspects of photography, he likes to explore many different subjects and techniques and tries to inject 'mood' into his pictures by use of printing and toning. *(140)*

Lesley Thoburn (Tyne & Wear)
Lesley took up photography 10 years ago and soon became hooked, setting up her own darkroom and concentrating on monochrome images. Recently she has been working on images which are thought-provoking, capture a certain mood, or simply tell a story. Lesley is an enthusiastic member of Gateshead CC. (58, 59)

Priscilla Thomas (East Sussex)
Priscilla acquired her first slr in 1991 and discovered photography as a means of creative expression. She gained her LRPS in 1992, ARPS in 1993 and – on her fifth attempt "with blood, sweat and tears" – the Fellowship in 1995. She has enjoyed numerous successes in national and international exhibitions. (33)

Alan Thompson (Surrey)
Alan has been interested in photography for over 25 years, concentrating mainly on monochrome. He is an Associate of the RPS and has begun to enter national competitions recently with some success. His current work is based around the process of lith printing and the use of selenium and gold toners. (119)

Kirk Toft (West Yorkshire)
Facinated by bromoils since he first noticed etching-like illustrations in archival copies of Amateur Photographer, Kirk's 'love affair' led him into two years of failed experimentation with the process. Six years on brought success and publication of work along with articles related to the process. (2)

Chris Upton (Nottinghamshire)
Chris is an Associate of the RPS and President of the Nottingham PS. A keen monochrome worker, his photographic interests are varied, but his favourite subjects are landscapes and candids. (131, 148)

Paul Warner (Devon)
Paul is a photographer and sculptor who is using his work to "explore thresholds within myself and the world as I experience it". He admits that many of his images perplex even him: "I find you can explore without knowing what you are going to find". He gained the fellowship of the RPS for his series entitled, Cabinet of Dreams. (21)

Gordon Western (Buckinghamshire)
Gordon still remembers vividly his wonder and delight as a child at seeing his father's contact prints emerge in the developer dish. It was only 15 years ago that Gordon had the space to create his own darkroom and to "set out on a voyage of discovery which was sometimes enjoyable, but often infuriating and frustrating". (104)

Paul Wheeler (Gloucestershire)
Paul has been a keen photographer for about six years and particularly enjoys monochrome photography, with his main interest being landscape. He regularly travels to the Glencoe, Rannoch Moor and Loch Etive areas of Scotland to photograph, as "the landscape is so dramatic and atmospheric". (133, 134)

Stephen Will (Northumberland)
Stephen started taking colour pictures in 1992 and in 1993 attended an evening class in photography at Northumberland College of Art. Here he was introduced to monochrome and has worked exclusively in black and white ever since. He sells a steady stream of framed prints and greeting cards, has had several portrait commissions and some pictures published in local newspapers. (160)

Catharine Willerton (Devon)
Catharine began taking monochrome pictures about five years ago after joining a City & Guilds course in Seaton. She gained her LRPS last year and at present is working towards her RPS Associateship. (23)

Roger Wilson (North Yorkshire)
After 10 years as a full-time professional photographer, Roger completed a three year degree course in Photographic Studies. Now, as a photography lecturer at the University of Sunderland, he has particular interest in 'alternative processes', pinhole and printmaking. He is an Associate of the RPS. (72)

Steve Zalokoski (Bristol)
Steve bought an slr camera in 1988 and hasn't looked back since. He has tried a wide range of techniques and styles in search of his 'niche', and became captivated by the magic of monochrome after making his first print. In 1994 he gained both the DPAGB and the ARPS distinctions: "I find that having something to aim for helps me produce 'the goods'." (56)

GLOSSARY OF ABBREVIATIONS

APS Australian Photographic Society

BPE British Photographic Exhibitor – 'crown' awards based on acceptances in recognised national salons

CC Camera club

CM Creative Monochrome – publisher of photographic books and magazines (including Best of Friends)

FIAP (translated as) International Federation of Photographic Art: awards distinctions, including Artist, Excellence and Master, based mainly on acceptances and awards in recognised international salons

IPSE Independent Photographers in the South East (UK)

LIP London Independent Photographers

PAGB Photographic Alliance of Great Britain

PS Photographic society

RPS The Royal Photographic Society (UK); awards distinctions of Licentiateship (LRPS), Associate (ARPS) and Fellowship (FRPS), mainly by assessed submissions of work.

slr Single lens reflex (camera using a mirror and prism system so that the subject is viewed through the taking lens)

UPP United Photographic Postfolios